THE MODERN IMAGE

Cubism and the Realist Tradition

organized by Sandra Shaul
for The Edmonton Art Gallery
December 11, 1981 to
January 24, 1982

SUPERVISOR OF PUBLICATIONS: SANDRA SHAUL
PHOTOGRAPHY:
AMBOS PHOTO DESIGN: FIG. 7
ART GALLERY OF ONTARIO: FIGS. 2, 5, 16, 25
ART GALLERY OF WINDSOR: FIG. 1
THE COLUMBUS MUSEUM OF ART: FIG. 11
THE EDMONTON ART GALLERY: FIGS. 12, 13, 28, 30, 33, 37, 38, 39,
40, 41, 42
THE METROPOLITAN MUSEUM OF ART: FIG. 19
MUSEE DU QUEBEC: FIG. 32
NATIONAL GALLERY OF CANADA: FIGS. 3, 4, 6, COVER, 8, 9, 10, 14,
15, 17, 20, 21, 23, 24, 26, 34, 35, 36
THE NEWARK MUSEUM: FIG. 18
THE PHILLIPS COLLECTION: FIG. 22
PUBLIC ARCHIVES: FIG. 43
COURTESY M. SCOTT: FIGS. 27, 29, 31
DESIGN: JOHN LUCKHURST, GDL
TYPESETTING: SET RITE TYPESETTING LTD.
COLOUR SEPARATION NEGS: BK TRADE COLOUR SEPARATIONS
LTD.
BLACK AND WHITE HALF TONE NEGATIVES AND PRINTING: SPEED-
FAST COLOR PRESS LTD.

THE EDMONTON ART GALLERY IS A REGISTERED, NON-PROFIT
SOCIETY SUPPORTED BY MEMBERSHIPS AND DONATIONS, AND BY
GRANTS FROM THE CITY OF EDMONTON, ALBERTA CULTURE, THE
CANADA COUNCIL, AND THE MUSEUM ASSISTANCE PROGRAMMES
OF THE NATIONAL MUSEUMS OF CANADA.

THE EDMONTON ART GALLERY
2 SIR WINSTON CHURCHILL SQUARE
EDMONTON, ALBERTA: T5J 2C1

CANADIAN CATALOGUING IN PUBLICATION DATA

THE MODERN IMAGE

BIBLIOGRAPHY: p
ISBN 0-88950-031-2

1. CUBISM — CANADA — EXHIBITIONS.
2. REALISM IN ART — CANADA — EXHIBITIONS.
3. ART, MODERN — 20TH CENTURY — CANADA — EXHIBITIONS.
4. ART, CANADIAN EXHIBITIONS.

I. SHAUL, SANDRA.
II. EDMONTON ART GALLERY
N6545 5 C8M6 709' 71'074011233 C82-091414-2

On the cover:
Lawren S. Harris
Lighthouse Father Point, 1930
oil on canvas
106.7 x 127 cm
Collection of The National Gallery of Canada

CONTENTS

ACKNOWLEDGEMENTS

Several individuals and institutions offered their assistance for the organization and mounting of the exhibition and the research and preparation of the accompanying catalogue. To Charles Hill, Curator of Post-Confederation Art of The National Gallery of Canada, I extend my greatest appreciation, not only for the information and direction provided, but also for often being able to clarify my own thoughts better than I could. Professor Ruth Bohan of the University of Missouri very generously supplied me with a copy of her thesis about Katherine Dreier and the Société Anonyme, before its publication, and answered my many questions. Dennis Reid, Curator of Canadian Historical Art of the Art Gallery of Ontario, provided valuable information about Lawren Harris and patiently listened to my ruminations.

Marian Scott and Louise and Charles Comfort very willingly filled many of the gaps in my knowledge of their careers and the period of Canadian art being discussed. John Vanderpant's family contributed in like manner. Helen Coy of the FitzGerald Study Collection opened her files and helped to piece some of the puzzles about FitzGerald's contacts and travels. Richard Bennett, Archivist of the Brooker Papers at the University of Manitoba guided me through the collection and the many different aspects of Bertram Brooker's career and character. Tom Hillman of the federal Public Archives allowed me to read about Canada's involvement with the 1937 Paris Exposition, and Joan Schwarz offered insights into the photographic scene in Canada. James Borcoman, Curator of Photography of The National Gallery of Canada, Susan Kismaric and John Pultz from the Department of Photography, Museum of Modern Art, New York also added many valuable insights to modern photography in general. A chapter of Toronto's art scene in the 1920s came to life with the help of Margaret Machell, Archivist/Records Manager of the Art Gallery of Ontario.

Finally, Terry Fenton, Director and Christopher Varley, Head Curator of The Edmonton Art Gallery were of great help and support especially in the editing stage of this publication, and Wayne Davis, Head Preparator, used considerable imagination to add flair to the installation.

Sandra Shaul

THE MODERN IMAGE
Cubism and the Realist Tradition
Introduction

Through the equation of modernity with national pride, the Group of Seven vitalized the Canadian art scene by the creation of a stylized new vision of the Canadian landscape. The Canadian artists to be discussed in this essay wanted to create a modern image of the world that would transcend the efforts of the Group. Unlike the Group, they did not work together or even as a scattered "movement" across the country. Yet the strong stylistic similarity of their art suggests that a common influence or stimulus did exist.

Compositions that are geometric to the point of implying the use of grids; of limited palette, and with most detail eliminated in order to emphasize form, characterized their "modern image" In the U.S., where art of this design first appeared about 1915, it became known as Cubo-Realism to describe its response to Cubism within the American realist tradition. Charles Sheeler, Charles Demuth and other Americans who developed this style were also known as Precisionists or Immaculates because of the clean line of their compositions. The realist tradition that was inherent to both American and Canadian art avoided the fracturing of forms and figures and the implication of ambiguous pictorial space, that began in Europe with Impressionism and was explored in new and more radical ways with Cubism. Multiple perspectives were never attempted although unusual ones were employed to give the appearance of greater abstraction.

In spite of the comparisons that can be made to the art of their American contemporaries, the Canadians had much less contact with European modern art, above all with Cubism. Subsequently we must look elsewhere to understand how the modern image came into existence. The title of the essay and exhibition is, in fact, an intentional snare for those who think that there was a parallel evolution, albeit slower, between European and Canadian, or American and Canadian art.

By looking at Lawren Harris's landscapes from the mid 1920s until 1930, the urban, rural and landscape subjects of Lionel LeMoine FitzGerald from about the same period, selections of paintings by Marian Scott and Charles Comfort from the 1930s, and finally photographs by John Vanderpant from the mid 1920s to mid 1930s, the style can be isolated and the routes that each artist followed to arrive at it can be traced and analyzed.

Although it recalls Art Deco, the movement that dominated the decorative arts and architecture in the '30s, the modern image in pictorial art is very much a separate and more complex issue. And it is equally removed from the contemporaneous bold imagery of social realism. By focusing upon this one small aspect of modern Canadian art the complex development of modern art in Canada becomes more apparent.

THE SPREAD OF MODERN EUROPEAN ART TO NORTH AMERICA

Just one year after Cézanne's death in 1906, Pablo Picasso started to show his recently completed canvas *Les Demoiselles d'Avignon* to his friends in Paris and thereby put into motion that explosive episode in the history of modernism known as Cubism. Picasso and Georges Braque evolved the aesthetics of both phases of Cubism, Analytical and Synthetic, between 1908 and 1914. Their ideas not only inspired many artists in Paris, but spread well beyond.

For Marinetti and the Italian Futurists, who had first evoked their revolutionary ideas in two Manifestoes of 1909 and 1910, cubist aesthetics were adopted to give their own compositions some visual coherence.

The English public was introduced to Post-Impressionist painting by two exhibitions organized by Roger Fry, held at the Grafton Galleries in London: *Manet and the Post Impressionists* (November 8, 1910 to January 15, 1911) and the *Second Post Impressionist Exhibition* (October 5 to December 31, 1912). Even though some of Picasso's cubist art was included in the second exhibition, Fry's heart would always rest with Matisse and Cézanne and never with Cubism. As his promotion of the Post Impressionists emphasized their break with the Impressionist aesthetic in order to re-emphasize line, form, and expression, the fracturing of form inherent to pure Cubism did not interest him. Fry's writing attracted much attention in North America. In Canada, Walter Abell, an American who became best known as the founder of *Maritime Arts*, the predecessor of *Canadian Art* and *Artscanada*, wrote in a style that was heavily indebted to the English critic.

Marinetti became a frequent visitor to London after 1910, the same year that Fry started his promotion of Post Impressionism. Several artists including Wyndham Lewis followed his more radical ideas in art. After a rupture with Marinetti, Lewis and Ezra Pound founded the Vorticist group in 1914. Vorticist art was based essentially on Futurism. Unit One, in the 1930s, included such well known figures as Henry Moore, Barbara Hepworth and Ben Nicholson and embraced not only Cubism but Surrealism and other vanguard pursuits.

Paris in the early years of the twentieth century, was the unchallenged capital of modern art, with Munich and Vienna also playing significant roles. But for the first time, an important secondary centre was to be found outside Europe: New York. The economic flowering of America and the social upheaval that had occurred through the end of the nineteenth and beginning of the twentieth centuries led many Americans to Europe for a variety of intellectual and cultural pursuits. Before World War I, the Steins, Gertrude and Leo, provided a salon in Paris where American artists could meet the Parisian avant garde. During World War I, a temporary French colony established itself in New York supported by wealthy American patrons whose collections often became the foundations of the modern collections in major American museums.

The "Eight" or "Ash Can School" led by Robert Henri, paved the way to the acceptance and assimilation of modern European aesthetics. Although their social and realistic subjects did not really deal with the formal concerns of the moderns, they did collectively demonstrate that the dictatorial bodies of conservatism, as exemplified by the National Academy of Art and Design, could be defied. Alfred Stieglitz, photographer and the first American dealer to exhibit modern French and American art, served as a pioneer for the presentation of this material to the new public, but probably more significantly as a catalyst to encourage others to follow this lead. They did so and often on a much grander scale than he could achieve in The Little Galleries of the Photo Secession at 291 Fifth Avenue or in his timely publication, *Camera Work*.

Although Stieglitz first published *Camera*

Work in 1903 and opened "291" in 1905, his heyday as a promoter of European modernism started in 1908 when he presented his initial exhibitions of work by Matisse (prints, drawings, watercolours and one oil) and Rodin (drawings). These were followed in 1911 with major exhibitions by Cézanne and Picasso, and in 1912, with sculpture and drawings by Matisse. In 1914 eight sculptures by Brancusi were displayed and in 1915 there were paintings and drawings by Picasso and Braque. But the Armory Show of 1913 marked the end of Stieglitz's role as the lone American spokesman for modernism. To the credit of both Stieglitz and the Henri group, the inspiration for the massive exhibition of European and American modern art was largely due to their efforts. Among the organizers were associates of the Stieglitz and Henri circles, and the exhibition included artists that they had first introduced to the American public.

The Armory Show was a turning point for the acceptance of modern art in America. Not only did it travel to Chicago and Boston, but it led to other major exhibitions including the Forum Exhibition (American moderns) of 1916 and the Pan-Pacific Exhibition in San Francisco, also held in 1916, which broadened the scope of modern art introduced in America by exhibiting Futurism on a major scale. From Stieglitz's lead, a number of commercial galleries opened, often accepting young American moderns that Stieglitz could not handle.

Also as a result of the Armory Show, several exciting "salons" appeared. Walter Arensberg was so moved by what he saw at the Armory on the last day of the exhibition that he and his wife Louise moved to New York from Boston. At first they made the acquaintances of some of the artists whose work he had seen and then some of the Arensbergs' literary friends started to take part in the growing circle. Arensberg was a writer and he counted among his friends such outstanding figures of the day as William Carlos

Williams. The overwhelming hospitality of the Arensbergs became known to the group of European artists who arrived in New York in 1915 and stayed until the termination of World War I. Marcel Duchamp, the best known of this group, initiated the American Dadaist movement, almost simultaneously with those in Europe. The American Dada was simply good humoured and anarchistic in contrast to the cynicism of its German and Swiss counterparts, created in the atmosphere of an absurd and destructive war. The Dadaist spirit is evident in the art of some of the Americans, most notably Charles Demuth, who were in the Arensberg circle.

The eccentric Mabel Dodge was introduced to modern art by the Steins in Paris and by Stieglitz in New York. She moved to New York in 1912 and her salons were known for the catholic mixture of people that attended. Artists moved freely among all of these groups.

Katherine Dreier founded the *Société Anonyme* in 1920 with Marcel Duchamp and Man Ray. Her exhibition of international modern art of 1926 - 27 is the accomplishment for which she is best known. In the '20s she replaced Stieglitz, the Arensbergs, Dodge and others as the champion of European art, and for the first time brought German Expressionism to the attention of the American public with as broad a presentation as French art had received in the Armory Show. Her German-American heritage and aquaintance with Kandinsky made this possible. It should be noted that English translations of excerpts from Kandinsky's landmark book, *Concerning The Spiritual In Art* had been published in June 1914 by the Vorticists in their first issue of *Blast* and even earlier by Stieglitz in *Camera Work* (July 1912). Kandinsky's text was highly regarded by American, European and Canadian artists as a rationale for nonobjective abstract painting.

The enthusiasm with which modern European art and artists had been greeted in the teen

years of the twentieth century quickly faded in the '20s. The Europeans moved back to Europe at the end of World War I. The Arensbergs, apparently exhausted by their New York life style moved to Hollywood in 1921. Mable Dodge moved to Taos, New Mexico in 1917, the art colony that would later attract such artists as Georgia O'Keeffe and Lawren Harris. Stieglitz closed "291" in June of 1917. His interest became limited to American moderns whom he felt were now being overshadowed by the surge of European modernism that had hit New York. In 1925 he opened the Intimate Gallery in the Anderson Galleries building which operated until the building was sold in 1929, and then he and friends started An American Place. Both galleries were devoted to a small circle of American artists. Stieglitz died in 1946, completely out of the mainstream of new American abstraction. But the most curious detractor of modern European art was Leo Stein. After having been one of the foremost American champions of modernism with his sister Gertrude in Paris, he returned to the U.S. as an arch conservative critic. Katherine Dreier's broad survey of international modern art at the Brooklyn Museum in 1926 and the creation of the Museum of Modern Art in 1930 were two highlights and exceptions to the search for the "American Scene" that was starting to dominate the thinking of American artists in the '20s and was firmly established by the '30s.

The Canadian painters that we are discussing, although artistically less than a generation apart, varied considerably in age. Harris was born in 1885 and FitzGerald in 1890. Comfort was not born until 1900 and Marion Scott is youngest, born in 1906. When the Armory Show brightened the New York art scene, Comfort was only thirteen and Scott, seven. FitzGerald was just beginning his artistic career in Winnipeg.

Before 1920, the responsibility of suddenly

disrupting the conservative Canadian art scene would have had to fall on the men who became known as the Group of Seven. Although these men were committed to the vitalization of Canadian art, the confirmation for the direction that they were taking did not come from the Armory Show which opened in New York in February 1913, but rather from an exhibition of Scandinavian landscape painting that Harris and J.E.H. MacDonald visited at the Albright Gallery, in Buffalo, one month earlier.

Some of the future members of the Group (Harris, Jackson and MacDonald) were already aware of the European modern art displayed in the Armory Show. But the northern landscapes by the Scandinavian artists had more appeal. For Canadians promoting the relevance of Canadian subject matter rather than pseudo-Dutch-cum-Barbizon, the bold yet haunting snow covered forms of the Scandinavian painters were more than subtle reminders of the northern wilderness that they had been exploring. The strong art nouveau lines and colour would have had immediate appeal to the Canadians, who with the exception of Harris, were professional designers. These same qualities, combined with the expressive spiritual sense that the paintings apparently evoked, gave them a symbolic significance. The painting style and subject matter were visually and emotionally distinctive; attractive to a broad public. With the opening of the first Group of Seven exhibition at the Art Gallery of Toronto on May 8, 1920, they presented the first major demonstration of their efforts.

In spite of accounts to the contrary, the Group of Seven were successful from this very first public appearance, and after the famous Wembley exhibitions of 1924 - 25, they were firmly entrenched as the new Canadian art establishment. Their activities are virtually the only artistic events discussed in regard to the Canadian (i.e. Toronto) art scene of the '20s, with the exception of the Société Anonyme exhibition of 1927. Were the visual alternatives limited to the academic paintings or slightly more radical work of the former Canadian Art Club? Was the only taste of modern art to be gleaned from the Group?

Few and far between, there were, indeed, some alternatives. From November 9 to December 8, 1918, The Art Museum of Toronto was host to a British Government exhibition of "official lithographs by her foremost artists, depicting 'Britain's Efforts and Ideals in the Great War'".[1] In the accompanying catalogue, speaking of the "liberal-mindedness" of the selection committee, it is noted that "even [a] cubist [is] included". This was a reference to several prints by C.R.W. Nevinson, a member of the Vorticist movement.

From January 8 to February 6, 1921, an exhibition of *American Contemporary Art* was held at the Art Gallery of Toronto. The show was organized because an exhibition of art from Toronto collections, held the previous year, only yielded two examples of American art.[2] It was considered timely therefore to explore this area. The exhibition was co-ordinated by Edward R. Greig, Secretary and Curator of the Art Gallery of Toronto, who managed to supplement an assembly of American paintings, recently exhibited in Chicago, with a selection by Walter Pach that displayed the modernist tendencies.[3]

This exhibition, held about mid way between the first Group of Seven exhibition and the second in May 1921, comprised paintings that for the most part seem to have been in the style of the Ten American Impressionists and their artistic descendants — landscapes, portraits, the American scene — and from contemporary newspaper reports, they were well and easily received. For our purposes, it is the reaction to Pach's selection that is of most interest. As was the installation style in Toronto, the "radical" paintings were hung separately from the rest, in a single gallery. Today, some of these artists have drifted into obscurity, and others such as Mary Cassatt or John Sloan, one of the members of Henri's "Ash Can School", would hardly seem radical. Paintings by A.H. Maurer, Morton Schamberg and Charles Sheeler, would, by contrast, have been novel to Torontonians. The newspapers give the impression that the more "radical" or novel art works were difficult to comprehend by those not acquainted with modernist tendencies and, as a result, less likely to be appreciated. These reports, at once assure the uninitiated viewer that he is not alone, and imply that it may be worthwhile to do some homework. A range of modern movements are mentioned, and therefore were obviously known even if only slightly. For the most part, confusion rather than hostility set the tone.[4]

Records show that 8240 people attended the Gallery to see the display and that 923 catalogues were sold, figures impressive by even today's standards.[5]

It may be assumed that the invitation was extended to Mr. Pach because of the associations that already existed with members of the Society of Independent Artists such as Maurice Prendergast and Ernest Lawson. They were expatriot Canadians whose work was regularly shown in New York and Europe, had been connected with the Ash Can School, and like several American artists, exhibited with the Canadian Art Club.

The attention that his exhibition appears to have drawn did not, however, tarnish the armour that the Group of Seven were rapidly acquiring, or change the very conservative direction of instruction adhered to by the Ontario College of Art and other less prominent art and technical schools. It should be remembered that the initial enthusiasm for the international avant garde was already waning in the U.S. As the American "radicals" were the result of this first wave of modernism, an episode that had by-passed the Canadians, it is not surprising that the Canadi-

ans were more comfortable with the nationalistic sentiments of the "American Scene". American post-war introspection and nationalism, as manifested in the art of the era, were not far from the sentiments of the Group of Seven and their growing public. Several other exhibitions of American contemporary art were organized in the '20s and '30s, minus the "radicals". It should be noted that the 1925 show did include paintings from the group of artists in Taos, New Mexico.

An exhibition of contemporary Russian art was also mounted in 1925. Nikolai Ulianov was described as a representative of cubist style art. But the exhibition that would come closest to causing an Armory Show jolt to the Canadian art scene was the *International Exhibition of Modern Art* assembled by The Société Anonyme in 1926.

KATHERINE DREIER
The Société Anonyme and The Canadian Connection

Lawren Harris, who had been most important in articulating the Group of Seven's philosophy of art and promoting it and the Group to the public, was also one of the first to see the limitations of the Canadian art movement once it was established. His own vision of modern art was broadened by his visit to the Société Anonyme's Brooklyn exhibition and with the help of Dr. Harold Tovell, Chairman of the Education Committee of the Art Gallery of Toronto (and owner of a Duchamp from the Quinn Collection), Harris convinced the Gallery to display an edited version of the show from April 2 to 24, 1927.

Dreier and Harris became acquainted after she first saw two of his paintings, *North Shore, Lake Superior* and *Ontario Hill Town* in the Canadian section of the sesqui-centennial exhibition in Philadelphia (1926). Dreier who wrote the foreword to *Modern Art at the Sesqui-Centennial Exhibition* was sufficiently moved by *Ontario Hill Town* to have it illustrated in the book and to invite Harris to participate in the Brooklyn show.[1] The combination of a strong geometric compositional style with an equally outstanding expressionist element was rare in American art and was probably what most impressed Dreier. Harris sent *Miners Houses,*

Glace Bay, c. 1925 (Collection of the Art Gallery of Ontario), similar in style to *Ontario Hill Town*, and *Mountain Forms*, (location unknown) to Brooklyn.[2] When he went to see the exhibition, he finally met Dreier and the collaboration to bring the show to Toronto began.[3]

While their friendship began on the basis of her attraction to his art, a great many similarities in their backgrounds seem to have lead to many common beliefs and outlooks; including an adherence to theosophy. Referring to Ruth Bohan's thesis: *The Société Anonyme's Brooklyn Exhibition, 1926-27: Katherine Sophie Dreier and the Promotion of Modern Art in America*, we find that Katherine Dreier was born in the U.S. of German parents. Her father was a partner in the New York City branch of Naylor, Benson & Co., a British iron works, and her mother came from an evangelical background. The Dreier family originated in Bremen, a city known for its democratic ideals. German was the only language spoken in the Dreier home, which in every other way also maintained its German heritage. By the time she reached her teens, Katherine Dreier could mix easily in both American and European company.

This compares with Harris's background as part of the established Massey-Harris fortune. He also came from a deeply religious family. His grandfather was a Presbyterian minister, his uncle a Baptist minister, an uncle by marriage was a Presbyterian minister, and his mother a very committed Christian Scientist. Both Harris and Dreier had virtually unlimited funds with which to devote their lives to art.

Although Dreier did not define the social role of modern art, it was certainly a crucial issue. Bohan states: "The emphasis she placed on the social role of modern art and on its relationship to the spiritual forces of the "new era" set the Société Anonyme radically apart from other promoters of modern art in America".[4] Her family were members of the Progressive Movement;

her sisters part of the Womens Liberation cause. From these roots, we find a zealous personality with the same tendancy to campaign as Harris. Whereas a lot of Harris's success owed much to his good looks and charm, Dreier's came from a large physical build and aggressive personality that often slipped over the brink into pure intimidation.

Dreier found a spirituality in Harris's art that was, in her opinion, lacking in American art. "She believed that the American artist, like the American public, was too distracted by the physical side of life to probe life's ultimate meaning and significance with sufficient clarity and skill. She greatly lamented the situation inasmuch as she considered a truly spiritual art essential to the country's well-being." She even compared America to ancient Rome, citing Rome's capitulation as a world power to an emphasis on material goods and the resultant de-emphasis on the fine arts.[5]

Dreier attacked representational art for being too literal, and felt that in abstract art, as had Kandinsky, that it was the content conveyed by the forms rather than the actual forms that was the true essence. Her initial contacts with Man Ray and Marcel Duchamp, co-founders of the Société Anonyme in 1920, were through their association with the Society of Independent Artists. Duchamp was particularly helpful in showing her how to perceive the spiritual content in art other than German Expressionism, but his Dadaist antics did not amuse her. Her rejection of Fountain by R. Mutt from the Independents exhibition of 1917 was based on her decision that it "lacked originality".

Although Dreier could never be referred to as the most perceptive and objective raconteur of the development of modern art, her contacts with the leading artists of the U.S. and Europe certainly gave her an edge over most participants in the North American art scene.

In 1923, Dreier published her first book of philosophy, Western Art and the New Era, which Bohan very succinctly and accurately describes as "an idiosyncratic permutation of the mystical teachings of theosophy, the metaphysical theories of Wassily Kandinsky, who was himself heavily influenced by theosophy, and the socially oriented aesthetic ideals of John Ruskin and especially William Morris, which Dreier employed to bolster her own views about the social utility of art."[6]

Although the original Brooklyn exhibition, which opened on November 18, 1926, did include a fair representation of Americans to present the whole modern scene to the public, the Anderson Galleries, Albright Gallery and the Art Gallery of Toronto were too small to carry the whole show. Stieglitz withdrew the artists associated with him and further editing removed most of the other Americans. Some pieces such as Brancusi's Leda were considered too fragile for so much travel. What remained for the eyes of Toronto was still a superb assortment of painting and sculpture from Cubism to de Stijl, Russian Constructivism, German Expressionism and Italian Metaphysics. Léger, Mondrian, Picasso, De Chirico, Duchamp-Villon, Gabo, Pevsner, Klee, Kandinsky and many others were all represented. Brancusi's Mlle Pogany was there too.

When Dreier came to speak in Toronto, the reaction from the general public was similar to that of the 1921 exhibition, only more so.[7] To some artists such as Harris and Comfort, the exhibition was seminal; a confirmation of new directions with which to experiment. Few artists, as this history demonstrates, would have been totally unaware of the art presented by the Société Anonyme; it is the impact of such an assembly that counts. Unlike the aftermath of the Armory Show, there was no flowering of commercial galleries or the rise of a new breed of collectors. The Art Gallery of Toronto organized two exhibitions in 1929 that may have resulted from interest aroused by the Société Anonyme. French Paintings and Sculpture included Matisse, Modigliani, Monet and others from the Kraushaar Galleries, New York, as well as Tovell's Chess Player by Duchamp and Head of Baudelaire by Duchamp-Villon. Paintings by Joseph Stella were borrowed from the Valentine Gallery, New York.

The presence of the International Exhibition of Modern Art did not create factions amongst the artists in Canada, but it did bring attention to the fact that they were emerging. Nowhere is this more telling than in two articles, placed back to back in The Canadian Forum of May 1927. Situated under the general heading of "Modern Art and Aesthetic Reactions", "An Appreciation" was written by Lawren Harris and "An Objection" by his former colleague in the Group, Franz Johnston. Harris very clearly and rationally explains the purpose of the exhibition, the varied approaches to abstraction, and responds to the most common negative remarks about the show. At one point he states:

Many people deeply interested in the future of Canadian Art feared that the direction shown in the exhibition might lure some Canadian artists from their path. That seems very unlikely. While the exhibition did stimulate creative thought and emotion and opened new and thrilling vistas, it would be almost impossible now for any real Canadian artist to imitate any European artist. Our way is not that of Europe, and, when we evolve abstractions, the approach, direction, and spirit will be somwhat different. Furthermore, the exhibition has enlarged the vision of many of our people, has awakened them to a greater range of ideas and new possibilities for our artists. This should keep them true to their own path and help clarify their particular direction.

Johnston's "objection" can be best described, in comparison, as rabid. In reference to the artists he contends: "I am confident that most of

the creatures that perpetrated these monstrosities have 'leprous brains', if any." He concludes by calling the art "mental miscarriages".

As the Group of Seven officially expanded into the Canadian Group of Painters in 1933, opinion was divided between those wishing to follow the old Group philosophy of creating Canadian Art (in their own image) or to follow Harris and others in the perpetuation and growth of art in Canada. It was in this atmosphere that the first explorations of the creation of abstract art took place.

LAWREN HARRIS And the Dilemma of Nationalism vs Abstraction

The North American artist working in the early years of the twentieth century found himself in a society that associated quality of art with fidelity to nature. If he wished to venture into the realm of abstraction, he generally reconciled the tradition of realism to its antithesis by keeping his subject "recognizable". Sometimes this meant the selection of a subject, that with only little modification, looked very abstract. But the more imaginative artist would find a subject that became a catalytic or generative force with which to understand and to formulate a process of abstraction. This appears to be the way in which Lawren Harris's painting of the 1920s, ending with the Arctic series of 1930, came about.

Jeremy Adamson, in his excellent account of Harris's career to 1930, carefully documented the various themes and periods of his paintings and writings, as well as the many artistic and philosophical influences.[1] The one serious contention that can be raised is the unique place that Adamson gives to occult and transcendental philosophies, most notably theosophy, as determining factors for both the content and compositional style of the landscape paintings from about 1922 to 1930.

Citing Harris's deepening interest in these philosophies after 1918,[2] Adamson turns to theosophical theory to analyse the paintings as he presumes Harris did, while neglecting to see how the art relates to the compositional style and choice of subject typical of Harris's work

prior to this period. Adamson also proved to be sympathetic to the literature by F.H. Housser on the Group of Seven. Housser, a close friend of Harris and also a theosophist, combined his support for the Group with a highly spiritual interpretation of their work.

A philosophical interpretation of Harris's work is by no means irrelevant. Transcendental and occult theories of life, including theosophy, had become popular in Europe and North America in the latter part of the nineteenth century and were still a strong presence well into the twentieth century. Parallels are often drawn between the highly articulated theories of abstraction expounded by Kandinsky and Mondrian and the philosophical tenets of theosophy.

It is not surprising that the pioneers of non-representational art would express the rationales for this art in terms of spiritualism as the logical abstract contrast to materialism or, by extension, representational art. The analogy, within the existing fine arts, was to music, the art of ordering sounds which are complete in themselves and do not require some sort of concrete or aural association. What these artists possessed, however, that Harris with a much less sophisticated artistic background and milieu in which to work did not, was the foundations of a plastic vocabulary which enabled them to work through increasingly more abstract approaches to their subjects until they could make the jump to creating effective visual and expressive compositions that were based on non-representational forms and colours.

In his catalogue essay for the *Cubist Epoch*, Douglas Cooper described Mondrian as having "seized on the basic structural principle of Cubism and rejected the rest, for he believed that art was above reality and that the painter therefore should not be concerned with it."[3] Mondrian, in his linear and colour balanced paintings which were created from about 1914, used the compositional structuring language of

Cubism to pursue and express a personal non-representational reality. Kandinsky, initially through the strong structural motifs of Jugendstil and his own innovative talents, was the first to create purely non-representational art.

It is curious to note that Mondrian and Kandinsky had paved the way for Harris twenty years before he followed comparable artistic paths to a distinct but aesthetically similar end. As an abstract painter, in varying degrees, for almost a quarter century before attempting a non-objective composition, what impeded Harris from making this important transition?

It appears that the main culprit was Harris's introduction of nationalism to his spiritual beliefs, and the subjugation of his aesthetic to this inhibiting factor. At its best, Harris's enthusiasm for enlivening the Canadian art scene included his assistance in starting the Arts and Letters Club to give people of all artistic disciplines a centre for meetings, discussions and demonstrations; the construction of the Studio Building to provide studio space for several Toronto artists, and his zealous campaign to bring the Société Anonyme show and Katherine Dreier to the attention of the Toronto public. At its worst, Harris's enthusiasm was manifested in his dependancy on the Canadian North as an inspiration as well as a subject that was easily represented in abstract form to be a figuration of his combined nationalistic and spiritual beliefs. In his own words

> [The] north country . . . at its best it participates in a rhythm of light, a swift ecstacy, a blessed severity, that leaves behind the heavy drag of alien possessions and thus attains moments of release from transitory earthly bonds.[4]

And although Harris shared with other Canadians a Whitmanesque vision of an emerging nation, as Adamson so eloquently states: "In Harris's view, Canadians had a special Manifest Destiny; not politically to possess the conti-nent . . ., but spiritually to regenerate their southern neighbours."[5]

Referring back to Harris's early studies in Germany and the urban subjects of Toronto produced in 1909-10, it is important to see what already characterized his compositional style before the Jugendstil influence of the Scandinavians or the renewed and more committed interest in occult philosophies that he may have first encountered towards the end of his student days.[6] Harris seems to have employed a number of set layout designs throughout his career, the best known being the simple grid with stress on the vertical, (fig. 1 *Buildings on the River Spree, Berlin* and fig. 2 *Old Houses, Wellington Street*) and this layout is prevalent in the paintings to be discussed.

In later house scenes painted from about 1920 to 1922, the subjects are portrayed in three rather than two dimensions, but detail and palette are restricted, and severe geometric line replaces the more decorative line that is visible in *Old Houses, Wellington Street*, and most characteristic of the landscapes painted after 1913 until the *Superior* series. It was in 1921, after the fall sketching trip in Algoma that Jackson and Harris travelled west to Lake Superior. Harris was smitten by the stark scenes before him and Lake Superior subjects dominated his oeuvre until 1928. It is also this phase of Harris's work that bears the most stylistic as well as philosophical references to some of the American moderns.

Harris's first recorded trip to New York City was from December 30, 1917 to January 7, 1918[7] which he arranged for some fellow army officers and himself. Although not all trips after this one have been documented, it appears that Harris made several visits to the city. Doris Heustis Mills, a friend of Harris, stated in an interview with Charles Hill that Harris was aware of the art of Stieglitz, Arthur Dove, and Georgia O'Keeffe, and also was familiar with Rockwell

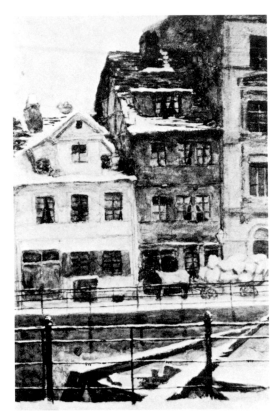

fig. 1
Lawren S. Harris
Buildings on the River Spree, Berlin. 1907
watercolour on paper
59.7 x 45.7 cm
Collection of the Art Gallery of Windsor
Gift of Mr. and Mrs. E. D. Fraser, 1971

Kent's work but did not meet him until he came to exhibit at the Art Gallery of Toronto in 1931.[8] She had met Kent in 1924, in his studio in New York, and had informed him of the resemblence to the Canadian's art. Even a *Mail and Empire* reporter, reviewing the 1922 Ontario Society of Artists' exhibition noted the common approach to simple design and use of colour by the two artists.[9] On the other hand, Doris Mills also saw Nicholas Roerich's work in 1924 and later spoke

to Harris of the apparent similarities in their art. Roerich was a Russian artist and theosophist who moved to New York and opened his own museum.

North Shore, Lake Superior, 1926, (fig. 3) while not representative of the ultimate plastic symbolism to be developed by Harris in future *Superior, Rocky Mountain* and *Arctic* canvases, in retrospect may be the most successful balance between philosophical message and pictorial morphology. The subject is a pastiche of various elements that, in Harris's mind, created the ideal image of the Canadian North and therefore a suitable set of icons to express his combined spiritual-nationalist philosophy. The lonely tree stump, proudly extending upwards towards the sky is placed on a bleak, stony terrain, facing the vastness of Lake Superior. A solidly structured bank of clouds, offsetting the strongly vertical tree stump, is balanced by equally solid diagonal rays of light, emanating from the upper left corner of the composition. The actual combination of elements — sky, tree, lake and rocks — was not a representation of an actual scene but rather the ideal grouping of the most impressive aspects of the Lake Superior environment.

In *North Shore, Lake Superior,* Harris eliminated descriptive detail from the objects that make up the composition, used a limited but striking palette, and through the use of bold line, emphasized form. As in the American paintings, the subject is an arrangement of abstract forms that are still sufficiently recognizable for compositional ordering to be based more on natural order than a formalist vocabulary.

The portrayal of the light rays is contemporaneous to those found in some American Cubo-Realist painting such as Charles Demuth's *My Egypt,* 1927 (Whitney Museum of American Art). For the Americans, light was neither illuminating nor an indication of time; it was simply another part of the landscape or other subjects, assigned a solid abstract form, thereby giving it

equal recognition to all other parts. Light is another abstract form arranged in such a way to create a successful abstract composition. To a degree, this treatment of light was the American adaptation of Cubism for the equal solidity that it accorded to the main figures of a composition and what had traditionally been the surrounding space. In the case of Sheeler, one can look even further to the architectonic painting devices of one of his favourite artists, Fra Angelico.

With Harris, one is reminded more of the spotlighting effect of the baroque sculpture of Ber-

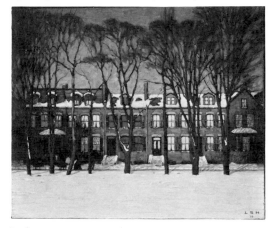

fig. 2
Lawren S. Harris
Old Houses Wellington Street, 1910
oil on canvas
63.5 x 76.2 cm
Private Collection

nini, combined with the mystical feeling of the 19th century Symbolists, to convey a sense of spirituality through light. The rays of light in the baroque sculpture are divine and serve to illuminate a well known religious sequence. Yet the baroque artists shared with the moderns the knowledge of how to architecturally balance their compositions with light.

Like his Gothic, Renaissance or Baroque predecessors, Harris had a spiritual message to convey through his paintings and he proposed

to accomplish this through a *symbolic* imagery. In place of the stories of Christian history or parables that give mortal and material substance to the spiritual messages that they deliver, Harris used the Canadian North. But the Canadian North and its inherent nationalism did not immediately evoke a set of spiritual beliefs to its viewers although it could give an overall sense of spirituality if portrayed dramatically. The already sparse scenery of Lake Superior or the snow-covered Rocky Mountains could easily supply the individual icons that Harris needed for his nationalist/spiritual beliefs, but how far could they be simplified and abstracted and remain effective? His spiritual beliefs were anti-materialistic but wrapped up in the nationalism of the North. Would a vertical figure or a triangle against a blue and yellow background ever evoke in his viewers what a cross does almost universally?

Stylistically, *North Shore, Lake Superior* can also be easily traced back to the grid and line of his early student work as well as to the horizontal line broken by the strong vertical forms and spotlit illumination of *Old Houses, Wellington Street.* It embodies much potentially theosophical imagery but is also visually similar to Rockwell Kent's "transcendental" landscape paintings and Emerson's poetry as Adamson remarked in this appropriate passage:

> Standing on the bare ground — my head bathed in the blithe air, and uplifted into infinite space — all mean egotism vanishes. I become a transparent eyeball; I am nothing; I see all; the currents of the Universal Being circulate through me; I am part or parcel of God.[10]

The Lake Superior subject remained an effective one for Harris. In *Lake Superior III,* c. 1928, (fig. 4) the composition is further simplified and refined. Three horizontal planes are formed by the land, water and sky, while the strong vertical direction is represented by two tall and gaunt

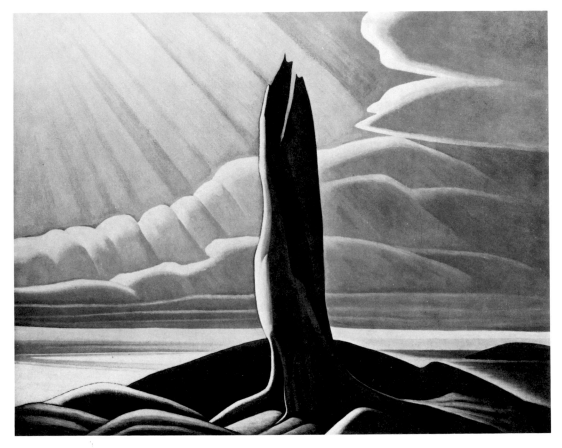

source of all spiritual flow") should have made them the perfect natural symbols of his spiritual beliefs. Through stylization of the natural scenes before him, the artist would have expected to be able to create the most highly resolved and inspiring expression of the spirit in paint. This assumption proved false as the discoveries of increasingly "spiritual" environments did not lead to the production of better and better paintings.

It has been frequently noted that the individual abstract shapes found in the mountain paintings are often the basis of the formal vocabulary

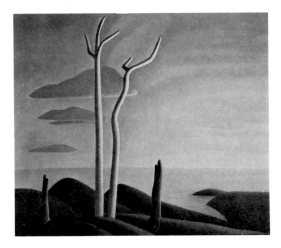

trees. Echoing them are two small stumps, miniatures of the grander version from *North Shore, Lake Superior*. The overall feeling of the painting is more serene and less dramatic. Three small clouds, again reminiscent formally of those found in *North Shore, Lake Superior*, replace the heavy cloud bank. The light enters from the left side of the canvas and is quite natural. The spiritual vortices have been replaced by the soft light of sunrise. The iconography is in place and it is a well resolved abstraction. Dramatic, it does not have the immediate, almost overwhelming impact of its predecessor.

fig. 3
Lawren S. Harris
North Shore, Lake Superior, c. 1926
oil on canvas
101.6 x 127 cm
Collection of The National Gallery of Canada

With his other northern subjects — the mountains inspired by his visits to the Rockies between 1924 and 1928, and the arctic landscapes produced from his 1930 voyage on the Beothic with Jackson — Harris did not achieve as positive results. The triangular formations of the mountains and the ideal location of the arctic landscapes at the top of the continent ("the

fig. 4
Lawren S. Harris
Lake Superior III, c. 1928
oil on canvas
87.6 x 102.2 cm
Collection of The National Gallery of Canada
Bequest of Vincent Massey, 1968

of Harris's later non-objective paintings. An example of this is the small painting *Abstract Sketch*, 1936 (figs. 5 and 6). In this way, the non-objective works were composed of these shapes removed from their obvious associations with natural formations. An interesting intermediary step between the development of these

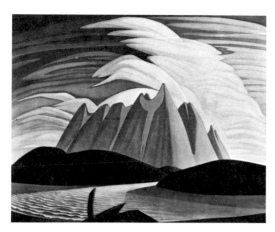

fig. 5
Lawren S. Harris
Lake and Mountains, 1927-28
oil on canvas
130.8 x 160.7 cm
Collection of the Art Gallery of Ontario
Gift of the Fund of the T. Eaton Co. Ltd. for
Canadian Works of Art, 1948

shapes and their use in the non-objective work could be the painting *Lighthouse, Father Point*, 1930 (cover). An analogy may be drawn between the guidance to safe and peaceful passage offered by the lighthouse to sailors and the more universal guidance of Harris's spiritual beliefs. In this way the lighthouse shared many of the qualities of the northern landscapes and would have attracted Harris's attention, for this subject, a man-made structure, was very rare at this point in his career. It is, therefore, important to study the formal treatment of the subject, specifically the means of abstraction.

This time the lighthouse is the obvious vertical element. But it is, in fact, the dual light sources in the upper and lower parts of the canvas that really maintain the viewers' attention. The bright red beacon, even more outstanding due to the contrasting light blue sky behind it, is the initial source of attraction. From there, one follows down the form of the lighthouse to the complimentary red forms: the roof tops of the nearby building. And it is in the lower part of the canvas that the focus remains.

In spite of the comparable compositional style of so many of the landscape and urban subjects, most notably *North Shore, Lake Superior*, the rhythmn of this painting works in the opposite direction, away from the sky. This effect is caused by the bright upper sky, subtly defined at the lower end by an arc that points downwards, and the more intense yellow spotlight that illuminates the lower part of the composition and adds a weightiness that anchors the viewers' eyes. As Harris had used the arc of light to accentuate the upward vertical movement of *Old Houses, Wellington Street*, here he has simply inverted it. The "baroque" spotlight on the houses, a technique used most extensively in the urban and Superior subjects to highlight the most "significant icon" or to manipulate the apparent overall configuration of a composition, is now used to draw the eye away from the predominant forms. As much as Harris may have been concerned with the spiritual content of his painting, he was also independently manipulating the formal content. In this way Harris succeeded in balancing and tying together a subject that contains a variety of focii in a more interesting way than in most of the mountain paintings.

The formation of the lighthouse structure bears an uncanny resemblance to the mountain forms, not only in the overall triangular configuration but in the three dimensionally portrayed walls with their hollow cores. The placement and appearance of the forms in *Abstract Sketch*, 1936 can be as closely linked to the structure of *Lighthouse, Father Point* as to the mountains. Consciously or unconsciously, Harris seemed to lift the vocabulary of the mountain formations and apply them effectively to another subject, while keeping a representational presentation.

A major transformation took place between the oil sketch (fig. 7) and final version of *Light-house, Father Point*. The light radiating from the beacon and the storm clouds in the sketch are replaced by a light, from an undefined source, and a cloudless sky, in the final painting. Although this can be interpreted as a transition from the specific to the universal by the shifting of attention away from the details of the stormy sky and beacon of light, the simplified final composition also became more balanced formally.

Charles Sheeler was fascinated by the relation of function to form, primarily in his paintings of Shaker architecture and artefacts, but in other subjects as well. The unusual perspectives, timeless quality, and elimination of detail can be credited as much to his desire to focus on the form and function relationship as to the

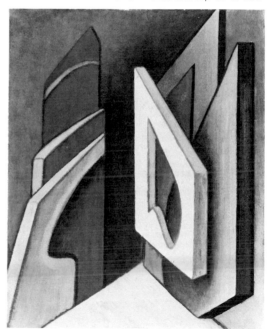

fig. 6
Lawren S. Harris
Abstract Sketch, 1936
oil on panel
37.8 x 30.2 cm
Collection of The National Gallery of Canada

modern aesthetics that, in part, made this permissable and provided the compositional means. His early training in industrial design and career as an architectural photographer are also important considerations when studying his approach to his subjects. To whatever extent visual comparisons can be made between a painting like *Lighthouse, Father Point* and a Shaker subject by Sheeler, the expressionist quality of Harris's work as a necessary component of even the most geometric abstraction draws him closer to Georgia O'Keeffe. As a proponent of the various forms of abstract art that were included in the Société Anonyme exhibition, 1926-27, one may also wonder if some of the more daring mountain paintings and *Lighthouse, Father Point* were experiments initiated by what Harris had seen.

Harris had passed the point of no return for becoming a solely abstract painter and found this troublesome only as far as his nationalistic sentiments persisted. They do seem to have been pervasive enough for Harris to have returned to explore new possibilities in less abstract formats. But from 1930 until his move to the U.S. in 1934 and his eventual resumption of committed artistic creation, Harris had to reassess the various objectives that he had felt painting must achieve and develop a new approach to the painting process.

Unlike his European predecessors, Harris could not use the spiritualism to which he strongly adhered as a basis for the creation of analogous abstract aesthetic theories because he had tried to identify very abstract ideals with very literal images. Harris's need to have his colleagues and himself create something uniquely Canadian through a particular landscape made such total abstract philosophy impossible.

It is the Arctic series (fig. 8), based on his northern voyage on the ship Boethic, in 1930, where the weaknesses in his attempts to coealesce the natural development of an abstract

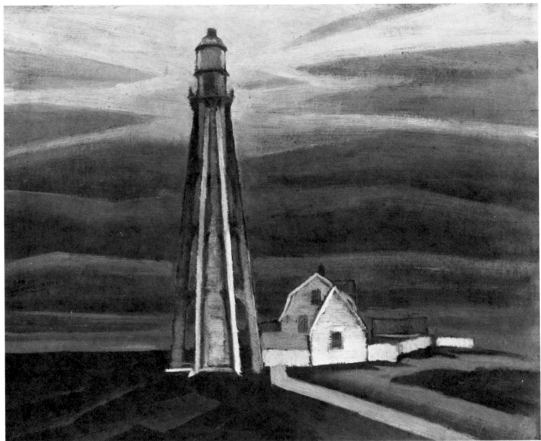

fig. 7
Lawren S. Harris
Lighthouse, Father Point. 1929
oil on board
30.5 x 38.1 cm
Private Collection

vocabulary in his painting with an aesthetic that was still influenced by his own mixture of spiritualism and nationalism, became most apparent. The failure of these compositions was even apparent to Harris, who by 1933 had virtually ceased painting and considered himself at an impasse.[11]

After the Arctic voyage and two summer sketch-ing trips in 1932 and 1933, Harris's representational landscape painting career was finished.[12] It is likely that with his realization that the Canadian landscape was not the visual key, in a representational format, to presenting his philosophy of life and aesthetics, he now had to re-examine his achievements and decide which direction that he would take.

The eventual decision to paint in a purely abstract, non-representational way was a logical one. The move to the U.S. in 1934 would have freed him from both his personal problems and his nationalistic crusade. From the mid-

thirties, landscape, and transcendental and theosophical philosophy became stimulii and guides instead of truisms. The experience of working with the transcendental painters group in New Mexico from approximately 1938-1940 may have further clarified some of the concepts associated with non-representational painting.

What role did theosophy play in Lawren Harris's early career? As his painting became more abstract from the Lake Superior series onwards, it appears that the geometric forms emphasized in the subjects are those that are fundamental to theosophical symbolism. The same is true of colour. While the compositions remained true to natural order, the process of abstraction, inasmuch as the decision to eliminate or accen-

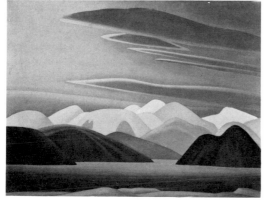

fig. 8
Lawren S. Harris
North Shore, Baffin Island I, 1930
oil on canvas
81.4 x 107.5 cm
Collection of The National Gallery of Canada
Gift of the artist, 1960

tuate certain forms and colours, relied heavily on theosophy.

But before theosophy had taken such a strong hold of Harris, the compositional patterns of his work were already established. And the importance that he attributed to landscape is equally rooted in the transcendental philosophy that

permeated so much of American, Canadian and even British thought. Walt Whitman's reputation was known far beyond American borders and *Leaves of Grass* was an extremely popular collection of his poetry. Even the stylistic similarities of Harris's painting to that of several Americans shows that he could have arrived at the same artistic conclusions, if not symbolic and spiritual, through different means. A fair knowledge of Kandinsky's *Concerning The Spiritual In Art*, in which some reference to theosophical thought is mixed in with many other theories, would have lead him down virtually the same road.

Harris was a zealot, and part of this was expressed in a desire to be truly modern; to be aware of the latest trends in everything and to believe that they were within his grasp. Artistically, this was most blatantly expressed in his ardent support of the different types of abstract art in the Société Anonyme exhibition, and its appearance in Toronto. Beyond his interest in art, it was expressed in the commission of a new home on Ava Road, Toronto, in 1931. Alexandra Biriukova, a Russian architect who had just settled in Toronto, was hired to create the design and Harris and his wife toured Europe to familiarize themselves with modern architecture. The April 1931 *Canadian Homes and Gardens* described the structure in an article titled "A Canadian Artist's Modern Home".

Abstract with Notes on Science and Art, c. 1935 (fig. 9) comprises a small, completely abstract pencil sketch, which is stylistically evocative of Kandinsky, but, in fact, is derivative of the mountain imagery. Surrounding the sketch is a series of statements about the nature of art.

Once again, an association with Kandinsky is possible, especially in statements like: "*Language* art every shape and colour, every relationship of shapes and colours line and volume has meaning, significance but not a meaning which can be put into words. The same with music."

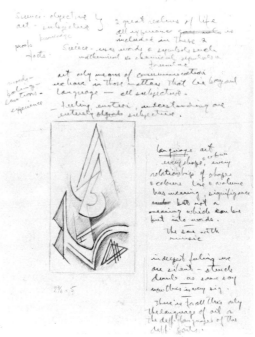

fig. 9
Lawren S. Harris
Abstract with Notes on Science and Art, c. 1935
graphite on wove paper
27.8 x 21.4 cm
Collection of The National Gallery of Canada

We finally see Harris leaving behind an artistic outlook restricted by nationalism and overly literal interpretation of a "universal" philosophy for one that has inspired a whole generation. Yet he was still approaching both art and philosophy as an evangelist, spouting slogans with the questionable depth of comprehension often characteristic of sloganeers. He may have also been reassuring himself through the repetition of these phrases.

A growing awareness and appreciation of Kandinsky beyond that which he could have acquired through his associates in Canada (the tovells, Bertram Brooker, etc.) could have come,

we have seen, from another theosophical source in the person of Katherine Dreier. Dreier may have also guided Harris away from his nationalistic associations with art.

In her foreword to the *International Exhibition of Modern Art* found in *Modern Art*, 1926 Dreier describes the growth and "power" of modern art as:

> bigger than any one nationality and carries the follower into a large cosmic movement which unites him in thought and feeling with groups throughout the world. Though this is true, it does not mean that it kills that strange quality which each nation stamps on its sons and daughters, but rather that nationality is no longer the whole substance, but a flavour which adds a charm.[13]

Harris, in his article "Creative Art and Canada", *Yearbook of the Arts in Canada*, written about a year after Dreier's statement, seems already to be debating the move away from a national art, based on a growing Canadian culture strongly distinct from any European or British aesthetic and cultural roots, to a more universal outlook. At first he states:

> Art in Canada in so far as it is Canadian is an upstart art. Its source is not the same as the art of Europe. The modern European artist serves "a consciously held idea of art" derived from its great treasure-houses of art, its museums, galleries, places and cathedrals. The Canadian artist serves the spirit of his land and people. He is aware of the spiritual flow from the replenishing North and believes that this should ever shed clarity into the growing race of America and that this, working in creative individuals, will give rise to an art quite different from that of any European people. He believes in the power and the glory, for the North to him is a single, simple vision of high things and can, through its transmuting agency, shape our souls into its own spiritual expressiveness. He believes

that this will create a new sense and use of design, a new feeling for space and light and formal relationships. He believes that what is termed "the great tradition" that informs all great art, cannot be taught. It is innate, and can only be evoked by great love of the indwelling spirit here and now. He feels that without such vision life would be mere mimicry, and he believes that, in every age and place, hidden in every true artist who has not succumbed to the perpetual doldrums, is a virgin ideal not unlike what has just been expressed.

But in his concluding paragraph, he explains how the artist must go beyond such specific references.

> Today the artist moves toward purer creative expression, wherein he changes the outward aspect of Nature, alters colours, and, by changing and re-shaping forms, intensifies the austerity and beauty of formal relationships, and so creates a somewhat new world from the aspect of the world we commonly see; and thus he comes appreciably nearer a pure work of art and the expression has been a steady, slow and natural growth through much work, much inner eliciting experience.[14]

One can surmise that by the time of this publication, written before his Arctic voyage, that through his own critical observations about art, and through his contact with the kindred spirit of Katherine Dreier, Harris was learning the process of abstract art and how it could be expressive at the most non-representational levels.[15]

Theosophy, which served Harris, in part, as a rational to creating abstract art, a guide to seeing the abstract direction that existed in his art, and through Katherine Dreier, an introduction to a broad range of modern art, also may have been the common ground for a Canadian exhibition in New York.

In 1931, Harris sent an exhibition of Canadian art to the Roerich Museum. This was not,

by any means, the first exhibition of Canadian art in the U.S. or more particularly New York, but Harris's decision to approach the Roerich Museum, and their decision to accept the exhibition may have been based on a "theosophical connection".

If Lawren Harris's ventures into abstract painting seem unnecessarily complicated in retrospect, even when compared to the other Canadian artists to be studied in this essay, it must be acknowledged that is was his evangelical zeal and promotion of abstract art that, to a great extent, made it acceptable for others to pursue. As a result, many artists and amateurs did gather together to discuss it in all its many forms.

LIONEL LeMOINE FITZGERALD
The Search for Structural Unity in Abstract Art

While Lawren Harris was vigorously fighting the twin causes of nationalism and abstraction in Toronto, one of the finest draughtsmen and painters that this country has produced was quietly and modestly exploring the different styles and methods associated with modern art of both French and American origins. Working in virtual isolation in Winnipeg, Lionel LeMoine FitzGerald's professional artistic career really commenced with his teaching appointment at the Winnipeg School of Art in 1924 under the direction of C.K. Gebhardt.[1] FitzGerald became principal, succeeding Gebhardt, in 1929. It was between 1927 and 1929 that FitzGerald's work was freed from the meandering typical of students and new artists, and began to show the maturity and vitality of an artist who had fully grasped the aesthetic problems set before him, and not only solved them, but did so with flair. One of the most fruitful periods of FitzGerald's career, 1929 to 1931, will be the focus for understanding his initial development of abstract art.

Even if it was only a brief term, the most important part of FitzGerald's education took place in the winter of 1921-22 when, at the age of 31, he became a full time student at the Art Students League in New York. Before this time, FitzGerald's training and exposure to art was sporadic — some local exhibitions, a few evening classes in 1909, art books and available reproductions, and visits to the Chicago Art Institute when he lived in the midwestern capital in 1910. Boardman Robinson and Kenneth Hayes Miller, two American scene painters in the anecdotal George Bellows tradition, were his teachers at the League and the many excellent museum and commercial gallery displays of modern and traditional art rounded his curriculum.

FitzGerald's response to French modernism was very North American. After some experimentation with Impressionism, he turned to Post Impressionist styles that maintained the integrity of form and line. Like the majority of his contemporaries, he was fascinated by Cézanne. An appreciation of well balanced, unified design and precise draughting may also have originated with his commercial publishing work.

By exhibiting at the Arts and Letters Club in 1928, he became well known to the members of the Group of Seven. They invited him to exhibit regularly with them, and finally, in 1932, FitzGerald was invited to join the Group. FitzGerald was strongly sympathetic to the goal of promoting art in Canada. Yet it may have been a combination of his training, which was undoubtedly reinforced by his association with the American, Gebhardt, and his isolation from the Group when they were at the peak of their creative rather than crusading powers, that determined his very different stylistic development. Although Harris managed to find "a suggestion of celestial structure and spirit from objective nature"[2] in FitzGerald's drawings at the Arts and Letters Club, FitzGerald, in fact, was following a route to abstraction that was much closer to the American formalists in the realist tradition. His palette was always cool, and his conception more that of the objective rather than passionately subjective observer. A comparable line exists in much of FitzGerald and Gebhardt's drawings but Gebhardt often introduced an anecdotal quality to his work that FitzGerald seemed to avoid. When human figures do appear in FitzGerald's work, they are reduced to forms, balanced with all others in the composition.

He was an admirer of some of the Toronto artists and did organize some small exhibitions of their work for Winnipeg, but in the matter of artistic models for himself, the French moderns had far greater appeal. Bertram Brooker, a former Winnipeger, made FitzGerald's acquaintance in Toronto in 1929. A consummate ad executive, astute writer on the arts, as well as a painter exploring modernism, Brooker kept FitzGerald informed about events outside of Winnipeg.[3] Brooker was a close associate of the Group but even he noted, in his now well known critique of their 1930 exhibition that: "The present show at Toronto rings the deathknell of the Group of Seven as a unified and dominant influence in Canadian painting The experimentation is over, the old aggressiveness has declined."[4] Perhaps even more revealing is a further expression of this sentiment found in a letter from Brooker to FitzGerald dated November 27, 1931 in which he describes a major international exhibition.

The American section, which was by far the largest of the course, contained many more interesting things than I expected. There is very little about them that you can call American, and yet they have enough vitality to be much more than mere imitations of French painting. Two landscapes by Rockwell Kent, which were the only things approximating to the Group of Seven sort of thing here, looked very flat and old fashioned compared with the majority of the American stuff.[5]

FitzGerald's 1930 diary from a major trip that he took through some major American and Canadian cities, is a valuable source from which to glean not only the general objectives of his aesthetic but the influences and personal decisions

which helped him to arrive at these objectives.[6] He would have had little leisure time between visiting art schools where he looked at classroom environments and talked to teachers, and his visits to museums, galleries and artists where he could become reacquainted with, as well as update his knowledge of modern European and American art. But in that leisure time he managed to record his observations. In the period following his year at the Art Students League, FitzGerald both through his own artistic activity and teaching was consolidating his philosophy of art. What he assimilated during his journey seems to have affirmed these concepts and even focused them further. This is shown in the subtle changes and improvements in the work produced after his trip.

Two themes prevail in the diary account of FitzGerald's aesthetic: compositional unity, and the balance of reality with abstraction. In the second theme, he distinguished the problems of tempering realistic or representational rendering with degrees of abstraction, and the relative importance of representation as content compared to purely formal considerations.

Of the Europeans, FitzGerald preferred the work of Seurat, Cézanne, Rodin, and Courbet. Of the Americans, he was particularly attracted to Sheeler and architectural drawings and paintings by others in presumably the same style. While visiting the Art Institute of Chicago, he saw Seurat's *Sunday Afternoon at the Grande Jatte*. In his words:

June 7
Seurat "Sunday in the Park" particularly enthused me. In this is a great feeling of reality and the people are really doing the things people will do in parks the world over. There is a real naievety through it all that only emphasizes the real quality and the color is beautiful, the feeling of sunlight extremely fine and the color seems to give the glow that sunlight has. The very remarkable thing is

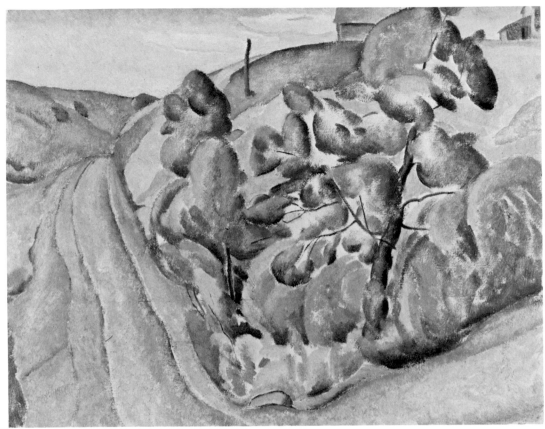

fig. 10
Lionel LeMoine FitzGerald
Untitled (Country Road), c. 1927
oil on canvas
30 x 38 cm
Collection of The National Gallery of Canada
Gift from the Douglas M. Duncan Collection, 1970

that on such a huge canvas, such a technique would hold together and be so simple in the great masses, all little strokes or spots broken pigment superimposed.

This is the first important reference to a technique which FitzGerald saw as creating compositional unity, and what surprised him was the fact that the unity was achieved through a consistent but extremely fragmented series of brush strokes.

During the same visit, he also saw a Cézanne about which he commented: "Strange after looking at it for a long time how it really begins to build itself and become extremely abstract, one forgets almost the houses and trees, mountains, water and sky in the intricacy of the design." Exactly two weeks later, on June 21, during a visit to the Metropolitan Museum he was confronted by five more Cézannes. He noted that: "Always the edges of the canvas is treated in a most careful manner, never at any point overdone but enough variety to keep the eye within."

But most of all he was again impressed by "the terrific sense of unity, everything being thought of to keep the eye within the picture and still it remains a thing of apparent ease. And always a great sense of reality no matter how abstract the thing may be."

Once again FitzGerald was fascinated by the formal unity of the compositions but even more by how, even in these quite abstract works, abstraction could be successfully integrated with reality (representation); how forms could remain intact. His appreciation of a Renoir in the Phillips Collection on June 12 brought him to the same conclusions but from the opposite direction.

"The gayety [sic] of the crowd absolutely alive yet behind it all the wonderful abstract design holding it all together This left the feeling that a story or incident as subject matter cannot destroy the art in it." His comments about the other Europeans follow in kind.

Untitled (Country Road), c. 1927 (fig. 10) was

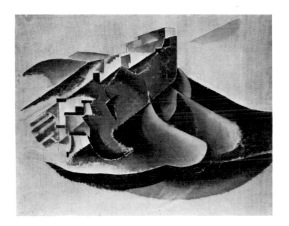

painted three years before his trip, but already FitzGerald employed a painting style that was evocative of Cézanne. He made a conservative effort to accomplish what he may have already sensed to be attributes in the master's technique. The subject of the painting is a curving road that borders a tree-lined hill on top of which are the barely visible details of farm buildings. The palette is quite limited, already a unifying factor, and the major forms of the composition are depicted from an angle that makes the viewer feel as though he is standing on a hill across the road at an intersection. The central focus of the painting is at the junction of a 90 degree angle. All forms in the painting come together to emphasize the inverted triangular format of the hill and road.

In his early career, Charles Sheeler did experiment with the new aesthetics of French abstract art. *Lhasa,* 1916 (fig. 11) was painted three years after the Armory Show. Perhaps the most apt description of this canvas would be a Mont Ste. Victoire painted by Braque. Using perspective according to Cézanne, Sheeler, who was at the time also toying with early Analytical Cubism, reduced the mountain and buildings on it to a pattern of simple geometric forms and planes. Sheeler, like FitzGerald, had worked as a designer and was an excellent draughtsman. He had a stronger grasp of French modernism, including Cubism, and more contact with the art and the artists. Sheeler also worked as an architectural photographer, revolutionizing this skill by taking photos of New York skyscrapers from unconventional angles which artfully attracted new attention to them. By the early '20s, he abandoned his more radical experiments with abstraction and developed what has been ironically termed a cubo-realist style. In fact, it was a rejection of Cubism; Sheeler, by this time, was fascinated by the relation of form to function and abstracted his subjects to objectively portray this relationship.

FitzGerald would, on occasion, use a modified pointillist technique or Cézannesque perspectives and style throughout his career. He too pursued architectural subjects and even his beloved trees in a manner that again could be thought of as cubo-realist. Considering that he never mentions Cubism, the fallacy of such a classification would be glaring. But we discover in the diary that not only did he admire Sheeler's work: "A drawing by Sheeler particularly attracted me, a pencil drawing of some low buildings seen against some skyscrapers, a very powerful extremely careful rendering,"[8] but he even emulated it (consciously or unconsciously) on the same trip. With his friend Osborne, a painter of architecture from Winnipeg who coincidently was in New York, he "went to a counter for lunch and then up to make a drawing of the New York Life Building somewhere around 20th - 23rd. Good fun trying the big building with the smaller ones in front with some overhanging branches directly in the foreground."[9]

The day before this session with Osborne, FitzGerald had paid a visit to the Roerich Museum.[10] Arriving before the museum opened, FitzGerald sat across the street and drew it (fig. 12). Special attention has been paid to the relative placement of the buildings along the street, the cars, and the tree which acts not only as a centrally placed focus, but also through its branches leads the viewers' eyes to the other parts of the composition. One thinks simultaneously of his remarks about the Sheeler drawing and of Cézanne's attention to edges. The same meticulous observation is evident in a drawing of a building detail and trees, also produced in New York, (fig. 13) and in another drawing of the trunk and details of branches of a tree in the same year (fig. 14). Stylistically they are close to Sheeler. When compared to a drawing of trees from 1923 (fig. 15), also a linear study of related shapes and forms in a conventional landscape composition, one can see the growth of Fitz-

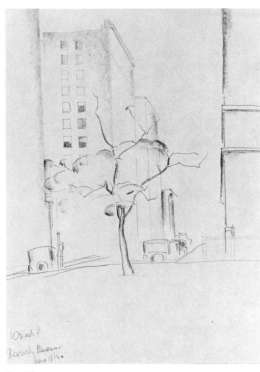

fig. 12
Lionel LeMoine FitzGerald
Untitled, 1930
pencil on paper
20.2 x 20.5 cm
Collection of the FitzGerald Study Collection,
University of Manitoba
Gift of Patricia L. F. Morrison and her heirs
Earl and Patsy Green

Gerald's abstract vocabulary and his facility in communicating with it.

The best summary of his observations appears towards the end of his stay in New York. While discussing abstract art with Lucille Blanch, the wife of Arnold Blanch (a former colleague from the Art Students League) he stated that:

Purely abstract had a tendency to lose contact with the living things which were the most important and that the move today is rather a swing toward an inspiration from

nature. An eternal contact with humanity and nature and a greater sense of unity.[11]
FitzGerald was never stymied by Harris's dilemma concerning pure abstraction for his objectives in creating art, at this time, were directed towards more physical than spiritual representations. FitzGerald also emerges as an observer of modernism that placed the French and Americans as two different, but equally valid groups to study. Sheeler and his contemporaries are never portrayed as watered down versions of Cézanne

fig. 13
Lionel LeMoine FitzGerald
Untitled, 1930
pencil on paper
23 x 18 cm (sight)
Collection of the FitzGerald Study Collection,
University of Manitoba
Gift of Patricia L. F. Morrison and her heirs
Earl and Patsy Green

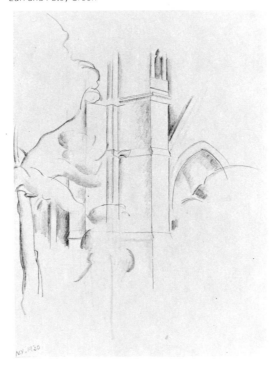

or Courbet, but rather as artists, who may have been introduced to the move towards abstraction by the French, but who had devised their own methods and aesthetic guidelines.

Georgia O'Keeffe's name does not appear in FitzGerald's accounts but there is a marked resemblance to aspects of her painting style in at least two of his canvases, *Pritchard's Fence*, c. 1928 (fig. 16), and *Doc Snider's House*, 1931 (fig. 17). The paintings, one pre-dating his 1930 trip, and the other following it, also serve to illustrate how the stylistic as well as the compositional unity finally gels in the paintings.

Pritchard's Fence is a divided painting due to two conflicting pictorial areas. Three quarters of the painting is about a row of houses that represent a study of rectangular and triangular volumes and how their appearance is affected by their proximity. In sharp contrast to the severe angularity of the houses, unbroken by the lacey branches of trees in front of them, is the fluid, undulating fence. Even the richly spread tones of brown paint contrast with the brusquely painted, neutral shades of the buildings. The row of houses follow a direction away from the foreground and the viewers which creates a sense of cool objectivity. The fence was undoubtedly intended to heighten the viewers' awareness of the overall design, much like the road in *Untitled (Country Road)*. Instead it confuses the composition both formally and for the subject it protrays. Logically the fence should fit easily in front of the homes and yards.

Georgia O'Keeffe was able to control two such diverse approaches to a single subject in such paintings as her *White Canadian Barn, No. 2*, 1932 (fig. 19). The whole composition echoes the overall long rectangular shape of the barn, which, in fact, occupies most of the canvas. The roof, a contrast to the plain white walls of the barn, looks more like a ribbon or a length of fabric that is floating on top. A perfect equilibrium is struck between the roof and sky, which

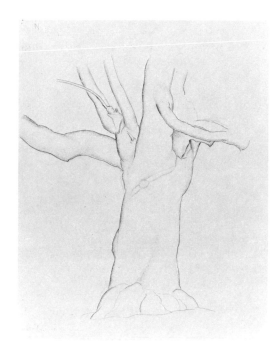

fig. 14
Lionel LeMoine FitzGerald
Trees No. 7. 1930
graphite on wove paper
34.8 x 27.8 cm
Collection of The National Gallery of Canada
Gift of the Douglas M. Duncan Collection

occupy the upper half of the painting, and the walls and ground which occupy the lower half.

In *Doc Snider's House*, FitzGerald achieved a comparable balance, succeeding with the same compositional objectives that characterize *Pritchard's Fence*. Once again, the homes recede from the picture surface and the viewers. This time a fence acts effectively as an indicator of the overall design, not as a dominant figure, but rather as part of a frame formed by the central house and the detail of the house on the right side of the painting. The whole composition is divided in half; the sky and buildings, and the snow covered yard. The trees, boldly displayed, also lead the eye through the design of the

painting. Although the trees, fence and snow are painted in a looser style than the buildings, the two different styles are each strong enough, and the subject clearly enough portrayed, that the composition is unified.

Whereas Sheeler's painting style eventually became very flat and patterned, FitzGerald's paintings of the period studied abstract volumes. A painting by George Ault, *Brooklyn Ice House*, 1926 (fig. 18), bears a stylistic resemblance to FitzGerald's paintings, especially the trees. Ault, like FitzGerald, was reacting to the developments in modern art within the American tradition and it is not surprising, therefore, that they derived like styles.

FitzGerald's response to modern American art was not confined to the aesthetic of the cubo-realists. Afterall, his teachers, while abstracting their subjects, presented them more

subjectively, and he looked to them as well as to the regionalists. Unlike the objective formalist perspective of *Pritchard's Fence* or *Doc Snider's House*, the viewer is transported into the centre of *Farm-yard*, 1931 (fig. 20). Although the feeling for the subject appears more detached than in the work of artists like Burchfield or Benton, there is more reaction to the atmosphere of the farm than in the earlier painting.

Working in isolation has been detrimental to many artists but for FitzGerald, in the Canada of the late twenties and early thirties, it may have been a blessing. As far as he was from the art

fig. 15
Lionel LeMoine FitzGerald
Trees. 1923
graphite on wove paper
21.6 x 33 cm
Collection of The National Gallery of Canada
Gift of the Douglas M. Duncan Collection, 1970

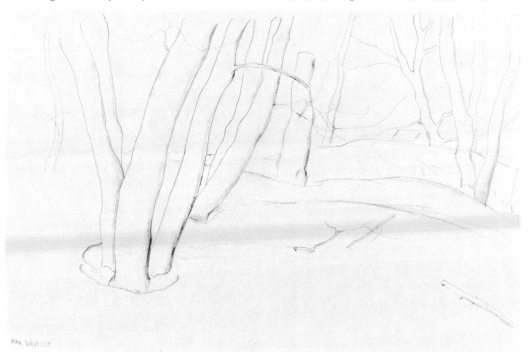

centres of Canada and the U.S., he certainly knew where they were and how to use them when necessary. His diary and art show that he had a much more sophisticated knowledge of modern art than any other members of the Group of Seven. FitzGerald was an excellent teacher and as such, was a keen observer with the bountiful curiosity of the ideal student. Minus the constant fanfares that marked every word and exhibition of the Group, he could systematically explore the problems that interested him about modern art.

fig. 16
Lionel LeMoine FitzGerald
Pritchard's Fence, c. 1928
oil on canvas
71.6 x 76.5 cm
Collection of the Art Gallery of Ontario
Bequest of Isabel E. G. Lyle, 1951

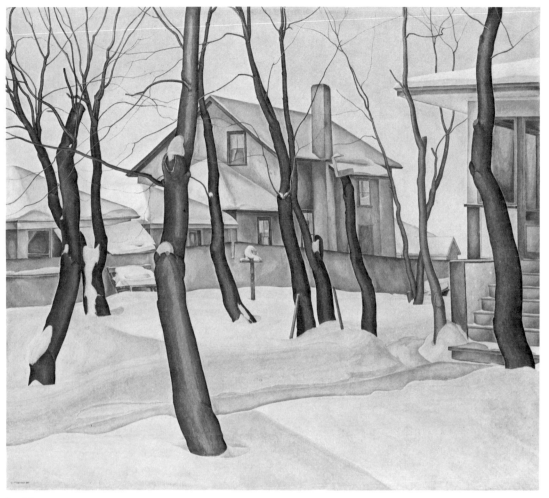

fig. 17
Lionel LeMoine FitzGerald
Doc Snider's House, 1931
oil on canvas
74.9 x 85.1 cm.
Collection of The National Gallery of Canada
Gift of Mr. P.D. Ross, 1932

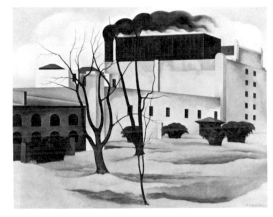

fig. 18
George Ault
Brooklyn Ice House, 1926
oil on canvas
61 x 76.2 cm
Collection of The Newark Museum

fig. 19
Georgia O'Keeffe
White Canadian Barn, No. 2. 1932
oil on canvas
30.5 x 76.2 cm
Collection of The Metropolitan Museum of Art
Alfred Steiglitz Collection, 1949
© Georgia O'Keeffe

fig. 20
Lionel LeMoine FitzGerald
Farm-yard. 1931
oil on canvas board
34.9 x 42.6 cm
Collection of The National Gallery of Canada
The Vincent Massey Bequest, 1968

CHARLES COMFORT
Expression, Design and Form

A broad observation of Charles Comfort's career shows him to be an artist who dabbled with many modern styles from the conventional route of French, German and American, to the less tread paths of the Mexican muralists and their American followers. Whereas an artist like Fitz-Gerald studied modern paintings and sculpture to clarify the aesthetic objectives of abstract art and then used his subjects as the bases upon which to apply his own abstract theories, Comfort appears to have started with his subjects and then turned to styles that could best express their most striking features. As a result, Comfort's art appears to be very eclectic for there is no apparent commitment to any established aesthetic or logical development of his own.

It is from about 1935 to 1940 that the geometrical abstract style of modern art appears in such well known paintings as *Tadoussac, Lake Superior Village*, and *Pioneer Survival*. The reasons for Comfort's sporadic pursual of the style, at the time, can be suggested, if not pinpointed. But a look at Comfort's background and how he applied the style to these and other subjects will illustrate his interpretation of the modern image.

Comfort studied at the Art Students League during the 1922-23 session. Before this, he had worked as an illustrator with Brigden's in Winnipeg. An award which he won through Eaton's brought him to Toronto in 1919 where he met various members of the art community.

He became a member of the Arts and Letters Club in 1920, shortly after his twentieth birthday, and also saw the Group of Seven's first exhibition that May. Returning to Winnipeg in the summer, he recommenced his design career with Brigdens and followed some art courses at the Winnipeg School of Art.

At the Art Students League, he studied with two formidable forces: Robert Henri who gave him a thorough foundation in technique, especially figure drawing and general draughtsmanship; and Euphrasius Allen Tucker, the editor of the Armory Show catalogue, who introduced him to French painting, as well as the writings of Clive Bell and Roger Fry. On a more conservative note, he also followed classes under Bonner, a student of Augustus John, at the 42nd Street School. Comfort derived the same pleasure as

fig. 21
Charles Comfort
Tadoussac, 1935
oil on canvas
76.2 x 91.4 cm
Collection of The National Gallery of Canada
The Vincent Massey Bequest, 1968

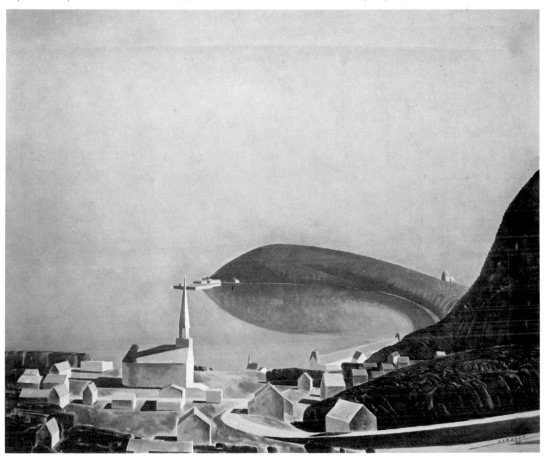

FitzGerald visiting museums and commercial galleries. Upon his return to Winnipeg, he pursued a dual career as an artist and a designer. In 1925, he moved to Toronto and maintained these activities while working for that city's office of Brigdens.

For Comfort, the true beginning of his commitment to modern art was with his experience of the *Société Anonyme* exhibition during its Toronto showing in 1927. He has made an analogy between it and the Armory Show of 1913. Serving as a docent for the exhibition, he had the opportunity to examine and to re-examine its contents very carefully. Comfort, with his close friends Bertram Brooker and Lawren Harris, frequently discussed the issues of modern art, as they saw them, and all three staunchly believed in the promotion of art in Canada rather than *Canadian* art.

Surrealism was a common topic of discussion in New York in the '20s and '30s, and according to Comfort, this was also true of Toronto. It reached the zenith of prominence in 1936 when Alfred H. Barr organized *Fantastic Art, Dada and Surrealism* for the Museum of Modern Art in New York. The Canadian National Exhibition mounted an exhibition of surrealist art two years later.

Comfort felt that his main areas of interest beyond French art were Kandinsky and the Bauhaus, not an unusual choice for a man who was both a designer and a painter of expressionist persuasion. His penchant for design and expression is again indicated by the American artists that he admired: Thomas Hart Benton, whose figures he described as folksy, Charles Burchfield, Edward Hopper for his simplicity, and Charles Sheeler.[1] The Albright-Knox in Buffalo was a relatively nearby source for the viewing of American art. Comfort won an award from that institution in 1938 for his painting, *Lake Superior Village*.[2]

Several important mural commissions came

his way, in the '30s.[3] Although similar in subject to Benton's murals, they are less rambunctious and much cleaner of line. Even though he was a member of the Bethune group, his work never displays the political, emotional ferver of Diego Rivera or the other socially motivated Mexican muralists.

In 1933, while on vacation visiting Robert Fawcett in Ridgefield, Connecticut, Comfort first met Charles Sheeler. Fawcett, a childhood friend and a fellow designer at Brigden's, Winnipeg, had been discussing Sheeler and Demuth with Comfort when realizing that Sheeler lived close by, offered to arrange the meeting. According to Comfort, he eventually met with Sheeler two or three times during his stay in Ridgefield, and discussed not only Sheeler's art but that of Kurt Schwitters and the Russian Constructivists. Comfort would already have been familiar with Precisionist art from at least the time of his student days in New York a decade earlier. Sheeler and Comfort met again in 1936.

While en route to meeting Robert Fawcett in Montmorency (outside Quebec City), Comfort visited Tadoussac and was particularly struck by the way an arm of land, near the town, extended into the St. Lawrence. The result was the painting *Tadoussac* (fig. 21) executed the same year as the visit, 1935. Affinities to Precisionism appear obvious and the meeting with Sheeler would seem to be the source. But this view oversimplifies the issue by denying everything else.

How close is *Tadoussac* stylistically to Sheeler's work? Both men are designers by training. In this painting, Comfort shared Sheeler's appreciation for the relative positioning of the forms of his subjects — the way they link — and eliminated all distracting, extraneous detail. The line of the extended land mass is echoed by the steep hill, outlined by the curving road, located in the foreground. The full sky subtly envelopes over half of the painting and is yet another ref-

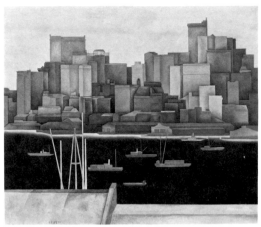

fig. 22
Stefen Hirsch
Manhattan, 1921
oil on canvas
73.7 x 86.4 cm
The Phillips Collection, Washington

erence to the rhythmic curves of the landforms. In contrast, the buildings of the town are solid immobile little structures that create a staccato rhythm. Augmenting this beat are the equally solid shadows. Together, they look like the architectural models used in three-dimensional plans. The perspective of the painting from a view slightly uphill over the town, is rather conventional, very unlike Sheeler, and the solid three dimensional rendering of the structures portrayed, brings more to mind the work of Stefen Hirsch, notably his painting *Manhattan* (fig. 22). Paul Strand, the American photographer, captured the same feeling for the rhythmn of the structures in his photo *Fox River, Gaspé* (fig. 23). What most distinguishes *Tadoussac* from all American Precisionism or cubo-realist painting, however, is the palette. The Americans used neutral or very warm colours. *Tadoussac* is composed of bright pastels; its outstanding feature being the exquisite blue of the sky. Perhaps Comfort owed that sky to Harris's *Lighthouse*,

Father Point, but more likely, it reflects his work as a muralist, an activity that was occupying him both as an artist and as a teacher at the Ontario College of Art. *Tadoussac* is a striking painting, viewed from both long and short distances.

The association with mural painting is undoubtedly true of *Smelter Stacks, Copper Cliff*, 1936 (fig. 24), whose industrial subject matter is drawn not from the American moderns celebrating the new industrial society, but from Comfort's related mural, *Romance of Nickel*, commissioned by the International Nickel Company of Canada for the Canadian pavillion of the Paris International Exhibition. It also refers to the romance of industry protrayed by Comfort in his murals for the Toronto Stock Exchange. These murals were based on the concept of those painted by Rivera for the San Francisco Stock Exchange. Unlike *Tadoussac*, the impact of the painting can only be felt from a considerable distance.

Cubo-realism, as an innovative style in American painting, was in its decline by the late twen-

fig. 24
Charles Comfort
Smelter Stacks, Copper Cliff. 1936
oil on canvas
101.6 x 127 cm
Collection of The National Gallery of Canada

fig. 23
Paul Strand
Fox River Gaspé. 1936
gelatin silver print
12.2 x 15.4 cm
Collection of The National Gallery of Canada

ties. When Comfort and Sheeler met, the American had already adopted an almost photo-realistic style for his *River Rouge Plant* series (1927-30) depicting the American auto industry. Subsequent to this series, Sheeler produced a number of works that juxtaposed a realistic rendering of objects in various interiors with a very subtle surrealistic sense of ambiguous time and space. From the 1940s, until the end of his career, the "precisionist" element in his art would best be described as a mannerism.

Comfort abandoned the "objective" regional-

ism characteristic of *Tadoussac, Smelter Stacks* and much precisionist art for the more anecdotal modes of Benton, Curry, Wood, and Burchfield in such paintings as *Lake Superior Village*, 1937 and *Pioneer Survival*. 1938. In *Lake Superior Village*. (fig. 25) the severe geometric style is not only maintained, but reiterated by the sharply

contrasting light and dark areas of the composi-
tion. Unlike *Tadoussac*, however, this does not
serve to heighten the viewer's awareness of the
physical formations in the painting, but rather
of a certain ambience. This is even more true of
Pioneer Survival (fig. 26) where the lone figure
standing in front of the small hut (centrally
located in the composition) must fend off the
overwhelmingly large elements of nature: the
uprooted tree trunks (in the foreground) and
menacing sky (in the background). The exagger-
ated forms of the roots and the clouds are used
more to create a sense of the odds of surviving
the life of a pioneer than to abstractly describe
the lay of the land.

This group of paintings exposes a side of
Comfort that was regionalist, but true to his
character, in no set way. Expression was always
of prime importance and the painting style
changed with the subject to be portrayed. When
comparing him to the American regionalists, he
would appear to have travelled between the
very subjective and anecdotal approaches of
Benton (also a muralist) and Burchfield, and the
very objective, analytical formalism of Sheeler.
Yet even at his most objective, in a painting
such as *Tadoussac*, there is a hint of dramatic
expression that allies him more with his fellow
Canadians than with his more formalist peers in
the U.S.

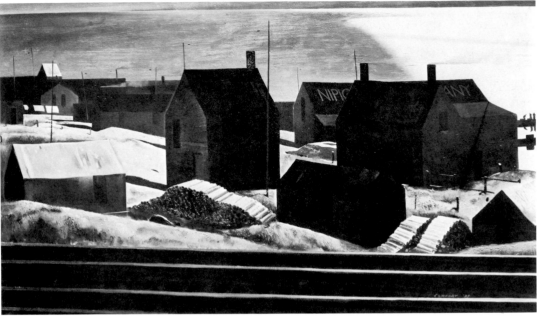

fig. 25
Charles Comfort
Lake Superior Village, 1937
oil on canvas
108 x 177.8 cm
Collection of the Art Gallery of Ontario
Gift from the fund of the T. Eaton Co. Ltd.
for Canadian Works of Art, 1950

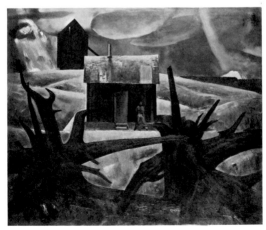

fig. 26
Charles Comfort
Pioneer Survival, 1938
oil on canvas
102.2 x 122.2 cm
Collection of The National Gallery of Canada
The Royal Canadian Academy,
diploma work, deposited 1945

MARIAN SCOTT
The Balance of Structure and Expression in Abstract Art

A cursory glance at Montreal painter, Marian Scott's work of the 1930s would lead one to believe that her course was comparable to that of Charles Comfort. Once again, a variety of subjects are treated in the mode of as many modern versions of abstraction. From 1937 to 1938, for example, there are a few paintings in which the figures are executed with the fluidity of line characteristic of Modigliani, an abstract protrayal of a crocus that immediately evokes the many floral paintings of Georgia O'Keeffe, and, in complete contrast, a foreboding geometric abstraction of a cement factory. There was, however, considerable reason behind these seemingly pendulous swings from free, spontaneous, fluid compositions to those that are very ordered with an economy of line and detail.

Scott, during that decade, was exploring the process of abstraction with the intent of creating a compositional style that was very logical, rational — clear to read — but that did not become so conscious of pure structure that all expressive and spontaneous content was lost. Her research into the work of other artists which appeared sympathetic to her own goals lead her to many diverse areas of modern art, resulting in the emergence of a style that was very much her own.

The early years of her art training were quite conventional. From 1917 to 1920 she followed classes at the Art Association of Montreal (later the Montreal Museum of Fine Arts) and from 1923 to 1925 at the Ecole des Beaux Arts. Both schools emphasized technical skills rather than aesthetic theory or concepts. During the academic year 1926-27, she was registered at the Slade School of Art in London. Studying under Henry Tonks, and attracted to the work of Frances Hodgkins, an artist plainly influenced by Cézanne, Scott also could have been introduced to the multi-facetted modern art scene by some of the followers of the Vorticist movement. But she did not attend classes regularly, preferring to use her student pass to make frequent visits to the National Gallery and British Museum.[1] Upon returning to Canada, she married Frank Scott.

By 1930 Marian Scott was painting in a style that was heavily influenced by the Group of Seven. Harris's Lake Superior paintings had attracted her attention, especially one depicting the ice house at Coldwell. Which painting this was, is unfortunately uncertain.[2] She also visited an exhibition of Jackson and Harris's Arctic paintings which took place at the Art Association of Montreal in January and February 1931. In fact, the Scotts eventually bought a Harris sketch that had been in the exhibition. Scott was impressed by the manner in which Harris retained and balanced the expressionist element with the highly ordered abstract format of the landscapes.

Whereas Harris's references to German Expressionism were based on his direct and indirect contacts with Kandinsky's theories on art, Franz Marc's diary, or at least excerpts, provided the same references for Scott in 1930. In her notes, she copied out at least one reference that was most in keeping with the philosophy of the expressionists: "Our minds already sense that the fabric of nature's laws conceals something that lies behind it, a greater unity".[3] Through reproductions initially, several examples of Kandinsky and Marc in the Contemporary Arts Society exhibition *Art of Our Day* in 1939, and finally during visits to the Busch-Reisinger Museum at Harvard in 1940, Scott had a fair exposure to German Expressionist art. She had been most impressed with Marc's *Tower of Blue Horses*, 1912.[4] As with other paintings of this epoch and in harmony with Kandinsky and other members of the Blaue Reiter, Marc was abstracting representational images to create new abstract symbols that would serve as an allegory of the "inner mystical structure of the world". The structuring system proposed by Cubism, was, to a great extent, the architectural framework on which the new symbols or images were arranged.

Closer to home, Marian Scott met Fritz Brandtner when he moved to Montreal in 1934. He also informed her about German Expressionism and she especially liked the "exuberance, inventiveness, energy" of his work.[5] John Lyman returned to Montreal in 1931 and, with his considerable talents as a writer and speaker, became an important source of information about European modernism for the local art community. Scott did sketch from time to time at his Atelier. And by this time, several commercial galleries liked Wm. Scott and Sons also carried French modern art.

It was not until 1935 that the British response to abstract art finally came to Marian Scott's attention, and then it was through a copy of *Unit One* published by the art group of the same name. *Unit One* represented the new wave of British modernism after Vorticism and included some of the former movement's members as well as Henry Moore, Barbara Hepworth, Ben Nicholson and Paul Nash. Scott was particularly attracted to the art of Moore, Nicholson and Wadsworth, and in an exhibition of her own work at the Dominion Gallery in 1954, the following quote by Moore from *Unit One* was cited in the catalogue:

Because a work does not aim at reproducing natural appearances it is not, therefore, an escape from life but may be a penetration

into reality, not a sedative or drug, not just the exercise of good taste, the provision of pleasant shapes and colours or a pleasing combination, not a decoration to life, but an expression of the significance of life, a stimulation to greater effort in living.

The quote is certainly consistent with the concerns that she was expressing and sympathetic to in abstract art, twenty years earlier. But the following quote from a letter written by Paul Nash to the Editor of the *Times*, found in the same publication, Scott has agreed, shows her objectives in creating abstract art to be virtually identical to the British.

It cannot be said that all of these artists practise "abstract" art, or that they are all interested in an architectonic quality principally, although this, perhaps, is a common pursuit with the majority Only the most stubborn can dispute that English art has always suffered from one crippling weakness — the lack of structural purpose. With few exceptions our artists have painted "by the light of nature". Even among the best, a fine or subtle composition seems the work of chance, or, surely it would occur more often. This immunity from the responsibility of design has become a tradition; we are frequently invited to admire the "unconscious" beauties of the British School — "so faithful to Nature". Nature we need not deny, but art, we are inclined to feel, should control.

It should be noted that the structure upon which expression rested in British art, often had cubist roots. This is most outstanding in the art of Nicholson and Wadsworth. In spite of the greater access that the British had to modern art and aesthetics, their reaction was to take the same liberties as their North American counterparts by assimilating as much as desired into their own traditions.

The American moderns provided still another area of interest. Like many of us, Scott would

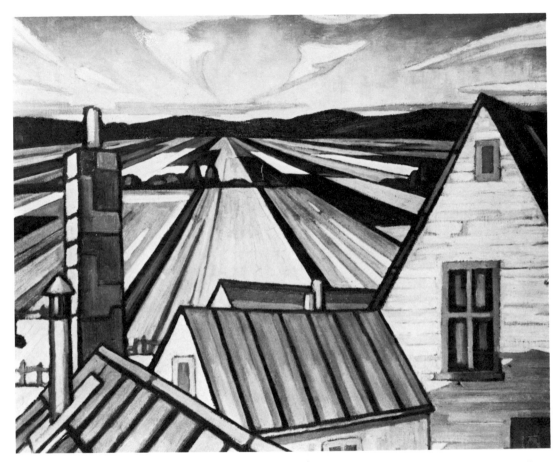

fig. 27
Marian Scott
Quebec Fields, 1931
oil on canvas
50.8 x 61 cm
Ontario Heritage Foundation Firestone Art Collection

spend two days in New York visiting as many exhibitions and seeing as much art as she could. In 1939, Scott exhibited a painting entitled *Wharf Road*[6] with the Canadian Society of Painters in Watercolour at the New York World's Fair. She remembers seeing American Precisionist art and and also being taken by the art of Juan Gris.

With Gris, not only was there the immediate association with Cubism, but as well, an approach to ordering abstract elements that would reappear in the art of Ben Nicholson. Scott did see the German Expressionist collection at Harvard in 1940 but coincidently, and to balance the score, she also saw an exhibition of work by Picasso at the Boston Museum of Fine Art. Within a short span of time, Marian Scott was able to study the structurally oriented formalism of the French and the expressionism of the Germans; two foundations of twentieth century art, as

well as the attitudes of the British and Americans with whom she shared more cultural affinities.

The paintings of the '30s show her to be most original and confident with the more architectonic compositional style, for the apparently freer curvilinear works are more completely derivative of other artists, as well as bordering on the purely decorative. Starting with *Quebec Fields*, 1931 (fig. 27) the stylistic influence of Harris is there but the intent is very different. As with Harris's mountain paintings or *Lighthouse, Father Point*, the predominant form in the composition is the triangle, but this time, it is not the

fig. 28
Marian Scott
Escalator, 1936
oil on panel
60 x 44.9 cm
Private Collection

fig. 29
Marian Scott
Escalator, 1936
oil on plywood
35.6 x 41.9 cm
Collection of King and Ruth Gordon, Ottawa

presumed symbol of a spiritual belief. Through its repetition, the triangle in *Quebec Fields* could naturally have served as a unifying factor of all the compositional elements, both from formalist and expressionist perspectives. One of the failings of the painting, however, is that the roofs of the farm buildings in the foreground form a triangular pattern that unfolds in a direction away from the field and sky, which zoom instead towards a single perspective point in the upper part of the composition. An ambiguous tension is subsequently created. Like Harris, Scott reduced her subject to a group of simple geometric forms but the heavy dark outlines and the strong warm colours which define the forms are also characteristic of the way in

which the Group of Seven treated their landscape subjects in the late teens and early '20s.

By the mid '30s, Marian Scott was one of a very few Canadian artists who turned to architectonically conceived urban and industrial subjects. Because of this, her paintings would first appear to bear a direct relation to American cubo-realism, but in keeping with the mood of the '30s, they express anything but the American optimism and admiration for their subjects. Rather one sees the artist's sense of fascination with each scene mixed with an equal sense of alienation.

fig. 30
Marian Scott
Escalator 1936
oil on canvas
57.2 x 76.2 cm
Private Collection, Toronto

Escalator, 1936 is a perfect example of Scott's unique abstract expression. How it came about can be revealed through two earlier paintings of the same subject, executed in the same year.

In the first painting (fig. 28) the composition is divided into active areas — the escalators and their passengers — and passive areas — the building spaces in which the escalators are found. The whole painting has been conceived in warm earth tones, with the people and escalators tinted predominately in reds, browns, and dark greys, and their surroundings in greens and light greys. This colour scheme is used in all of the escalator paintings. There is no attempt to conceal the brushstrokes as was common in American cubo-realist painting. In fact, their brusqueness complements the general mood of the painting. The overall movement of the composition is towards the upper right hand corner, away from the viewer.

Scott was evidently fascinated by the steady machine-like passage of the anonymous figures in the painting and wished to further refine the formal structure that would help convey this. The second painting (fig. 29) is based upon a close-up of the "boat" configuration found in the lower left quadrant of the first painting. Scott was exploiting the idea of creating a system of strong geometric images that would express the dynamics and theme of the painting as much as the actual subject. The composition is more dynamic because it is less complicated; there are fewer figures and building details, and these are more acutely defined. The "boat" (the space surrounding the lower escalator) points towards the upper right of the composition, its shape reiterated by the groups of passengers travelling upwards on the two levels of escalators.

The increasing tightness and simplicity of the second painting is pushed even further in the final composition (fig. 30). Scott turned back to the full subject of the first version, but has compressed it; squeezing and elongating the compositional elements thereby creating the illusion of a dynamic wedge. There are fewer people and those remaining are completely anonymous, highly delineated and geometricized symbols of the dynamism yet alienation of modern life.

Two paintings from 1938-39, *Cement* (fig. 31) and *Fire Escape* (fig. 32) again utilize exaggerated architectural angles and lines, combined with closely cropped perspectives and limited detail, to comment on modern industrial society. The odd mixture of fascination with the structures, while portraying them as virtual symbols of alienation continues in these paintings. *Harbour*, 1939 (fig. 33) is one painting in which Scott did concentrate more on the formalist conception of her subject. Gone is the expression of alienation and there is no other strongly stated emotion to replace it. Instead there is the documentation of her observation of how, through her system of closely cropped perspectives, the bow and housers of a ship, barely visible on the right side of the composition, define the form of what we can see of the ship in the centre of the composition. Even though the subject remains static, there is a sense of animation and amusement in the manner in which the figures on the pier are partially hidden by a houser, and the circular forms on the bases of the anchors become eyes on the "face" of the central ship.

By 1939, Scott had developed a clear personal approach to her industrial and urban subjects. Her equal concerns for the formalist and expressionist qualities of this style prevented the paintings from becoming mannered or mechanical; mere industrial pastiches or designs. After the outbreak of World War II, Scott left these subjects, and turned to more organic ones.

As Scott's professional career started to grow in the '30s, she had people who were not only enthusiasts, but also well informed, and in her own city, to guide her there and elsewhere.

Ironically, FitzGerald and Comfort studied in New York less than five years after Harris paid his first visit to the city. Harris ventured out as the gentleman artist-explorer, socialite, and amongst like-minded spiritualists. Comfort and FitzGerald saw modern developments in art as students in an established institution and remained closely allied to art schools, as teachers, for many years. Yet Harris remains the pioneer.

fig. 31
Marian Scott
Cement, 1938-39
oil on canvas
58.4 x 67.3 cm
Collection of The Faculty of Law, McGill University

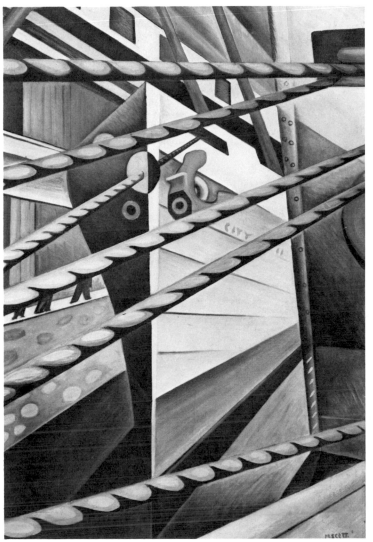

fig. 32
Marian Scott
Fire Escape, 1938-39
oil on canvas
76.5 x 51.1 cm
Collection of the Musée du Québec

fig. 33
Marian Scott
Harbour, 1939
oil on canvas
74 x 51.2 cm
Collection of The Edmonton Art Gallery
Purchased in 1980 with funds
donated by Canada Permanent Trust

35

JOHN VANDERPANT
A Pictorialist's Struggle with Modernism

In the latter part of the 19th century, pictorial photography appeared as an innovation that departed from the conventional use of the medium for pure documentation. With the purpose of having their pictures recognized within the realm of the fine arts, some photographers took the approach of emulating some aspects of contemporary painting by choosing similar subjects, using soft focus and in the printing process, simulating brush strokes. Another group within the pictorial movement felt that through purely photographic means; by the manipulation of light rather than the printing process, pictures of artistic merit could be produced. This photography for its own sake was known as "straight photography". The argument for straight photography from about 1910 until the 1920s in New York, and eventually throughout the U.S., became entangled in the more general rallying cry for modernism.

The association of straight photography and modernism became a central issue with a very high profile when Alfred Stieglitz through reproductions and articles in *Camera Work* and his exhibition programme at "291" interspersed modern art with photography. With the added impetus of the Armory Show and the influx of European artists during World War I, three pictorial photographers began to look especially to Cubism for new ways of approaching their own medium. Two of the three, Charles Sheeler and Morton Schamberg, were also painters; the

third and most talented was Paul Strand who was also a cinematographer. The potential dilemma of straight photography, as even Stieglitz saw it, was that so much emphasis would be placed on the mechanics and the need to avoid any non-photographic manipulation, that expression would be lost. Strand, Sheeler and Schamberg, who came to Stieglitz's attention between 1914 and 1917, proved that this problem could be skillfully circumvented.

Stieglitz, as a straight photographer, looked to the monolithic architecture around him, the symbols of American dynamism, and portrayed them in a distinctly modern way by emphasizing their clean, sharp geometry. This was achieved by reducing them to their fundamental forms by printing them in very contrasting tones and cropping very tightly within the full picture plane.

Strand, Sheeler and Schamberg, with a more profound understanding of Cubism, combined modern appearance with underlying aesthetic principles. For them, cubist painting was the means of seeing, in a very new way, three dimensional subjects within the confines of two dimensions. It provided an abstract order that not only revealed the form of objects but which also examined their textural qualities. Like the American painters, they never fragmented objects or created spatial ambiguities in their compositions.

Sheeler, primarily through the cropping of his subjects, disassociated them from their functions as part of larger entities, and thereby drew attention to their physical qualities as objects. Furthermore, he created patterns of surface textures that recall synthetic cubist collage. *Pennsylvania Barn*, 1915 (fig. 34) is a classic example.

Strand took two approaches to his equations of cubist philosophy to modern photography. *Abstraction*, 1916 (fig. 35) which was reproduced in the June 1917 issue of *Camera Work*, used a posed subject. By cropping the final image and printing it as a vertical rather than horizontal composition, he created a two-dimen-

sional, clean-lined abstraction of geometric forms and patterns. The second approach is best represented by *White Fence* (fig. 36), which was reproduced in the same issue of *Camera Work*, and used an unposed subject. From a purely formal point of view, the principal geometric configurations are held together by their situations within three horizontal and parallel planes, and by the rhythmic light and dark tonal contrasts. The composition is very flat. Yet from a literal point of view, the subject is easy to

fig. 34
Charles Sheeler
Pennsylvania Barn, 1915
gelatin silver print
19.3 x 24.3 cm
Collection of The National Gallery of Canada

recognize and clearly within three dimensional space. "The demands of objective documentation, expressive power, and modern appearance are all met in *White Fence*."[1]

Edward Weston took up the cause of straight photography in California, forming a group in 1932 known as f.64. Another development in the '20s was the incorporation of modern imagery into commercial photography. Advertisers soon discovered that sharp-focused images, close-cropped compositions and layout that

exploited the dynamism of diagonal line made their products look more up-to-date and appealing. For these photographers, the aesthetics of modern art were no longer a consideration; they were following photographic precedents.

Vancouver, from the mid-twenties to mid-thirties appears to be the centre in Canada where the pursuit of the modern image turned up in photography. The energy behind this endeavour belonged to a Dutch photographer, John Vanderpant, who arrived in Canada in 1911 at the age of 27, and established his own photograph

fig. 35
Paul Strand
Abstraction, Porch Shadows, Twin Lake, Conneticut, 1916
photogravure, published in *Camera Work*, June 1917
24.2 x 16.2 cm
Collection of The National Gallery of Canada
Gift of Dorothy M. Eidlitz

and art gallery in Vancouver in 1926.[2] The Vanderpant Galleries and their imaginative proprietor, on a very modest scale, brought together and publicized all of the contemporary arts from painting and photography to music and theatre, in much the same way that Stieglitz and "291" had in New York. As a photographer, Vanderpant towards the end of his very curtailed career (he died of cancer in 1939) found himself at the crossroads of the ways that 19th and 20th century photography had parted, as well as the factions of modern photography as they existed by the '30s.

Vanderpant had been successfully producing

fig. 36
Paul Strand
White Fence, Port Kent, New York, 1916
photogravure, published in *Camera Work*, June 1917
17 x 22 cm
Collection of The National Gallery of Canada
Gift of Dorothy M. Eidlitz

and exhibiting soft-focused pictorial photographs of urban and labour scenes, evocative of the British painter Frank Brangwyn.[3] In 1925, photos that he had entered in the Royal Photographic Society of Great Britain received good reviews but also comments on the lack of Canadian content. Perhaps for this reason, Vanderpant turned to subjects that were easily identifi-

able as originating from his adopted country. His choice was the grain elevators surrounding Vancouver harbour. While it is true that the elevators are outstanding structures in Vancouver, of the many other equally remarkable subjects, the grain elevators distinguished themselves by their ready international recognition. Le Corbusier, in his popular book *Vers une architecture*, 1923, described the North American grain elevator as the "most significant contributor to architecture for its unified expression of the engineer's mathematical precision and purpose."[4] The elevators dominate the photographic compositions, making it impossible to be unaware of their form and through such titles as

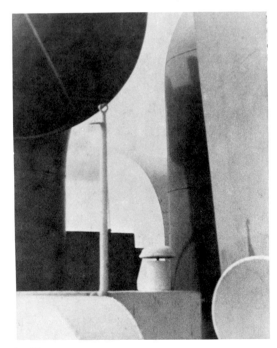

Temple of Trade, their economic importance is also acknowledged. But there is no sense of their modernity or vitality expressed through formal compositional means. The arrival of Frederick Varley in 1926 and their ensuing friendship naturally led to general discussions about art and the character of the land.

It was not until 1929 that Vanderpant started to experiment with the modern issues of photography that had been pioneered almost fifteen years earlier. Some of this experimentation took place during visits to Toronto and Ottawa where his work was being shown. Most of what he learned was gathered through camera periodicals which were easily available, and the rest from his travels. Unfortunately commercial assignments prevented him from continuing in new directions for about three years.

Philosophically, Vanderpant showed most affinity to Paul Strand. The subjects that he chose to photograph and his treatment of them, bear obvious influences of both Weston and the eastern photographers. But the persistent soft focus, use of tonal paper, and significant retouching at the time of printing, mark him as an artist that always had one foot firmly anchored in the early precepts of pictorialism, as did his use from time to time, even as late as 1935 of poetic titles.

In *Functional Beauty* (fig. 37), and *Untitled* (fig. 38), both of 1929, the use of severe cropping has drawn attention away from the functional aspect of the design of the industrial equipment. As a result, abstract compositions of related forms and textures were created. Conceptually and visually, the photos are close to Sheeler's work of 1915 to 1917, although they lack the crispness of line and extreme tonal contrasts. *Shadow From Fence on Sidewalk, Feet Walking Away*, c. 1934 (fig. 39), due to the presence of a shadow, and the dominant pattern that it caused, immediately recalls Strand's posed abstract photo. Vanderpant, unlike Strand, did not extre-

mely crop or disorient the perspective of his subject when printing, in order to keep it recognizable. In fact conceptually, this photo is closer to Strand's *Photograph* (white fence), although it still lacks the American's clarity of focus.

Two series of photographs do emerge in the 1930s that best show Vanderpant as an accomplished photographer. In the latter group, dating from about 1936, details of various plants and vegetables fill the whole frame. Vanderpant described these photos as the way "to emphasize the rhythm and beauty of design in nature's architecture",[5] and Charles Hill furthered this statement by describing them as showing "the relationship of the parts in the purpose of the

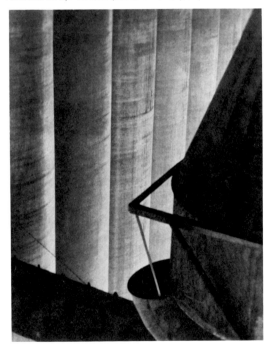

whole."[6] Primarily because of the subject matter, especially one photo of a halved cabbage, this series is immediately compared to the photography of Edward Weston and his f.64 aesthetic. Comparisons must really end at the subject matter, for in the face of Vanderpant's extremely poetic expressions of form and design, the f.64 theories were based upon the extreme limits of depth of focus, previsualization of the whole compositional image before exposure and accordingly, no manipulation of the negative or cropping and enlargement at the time of printing. Weston and his followers printed by direct contact onto glossy paper and vigorously gave technique precedent over expression. Vander-

fig. 39
John Vanderpant
**Shadow From Fence on Sidewalk,
Feet Walking Away.** 1934
silver bromide print
27.5 x 35.5 cm
Private Collection

pant was, however, interested enough in Weston and modern photography in California to organize an exhibition of his and Imogen Cunningham's work at the Vanderpant Galleries in 1931.

The former series was produced in 1934 and concerns increasingly abstract treatments of grain elevators. During a lecture tour across the country in 1935, Vanderpant described the elevators:

In their rigid strength and sublime simplicity they are the unpretentious temples of trade and a trade more vital — through distributing and storing of essential grains — than any other One may have to learn to "see" these elementary creations — which in their combination of simplicity, severity and usefulness reflect the vitality of a modern, perfect, architectural form display The photographic print gives strength of form and cement, the tenderness of beauty of texture, the design possibility in form and shadow they give an almost religious adoration of significant form.[7]

What these photographs may lack in technical prowess is easily overwhelmed by the originality of their abstract expression. Starting with a simple, straight forward documentation of *Pool No. 1 with Traintracks Foreground* (fig. 40), he then managed to achieve such compositions as a flock of birds silhouetted against a soft grid of silos (fig. 41) and the soft tonal undulating rhythmns of an elevator reflected in water (fig. 42). Without the reference of the documentary photo, the subjects would be virtually impossible to identify.

Whereas Strand created his most abstract photographs by presenting arrangements of ordinary objects in unfamiliar contexts and cropping them to the extent that their identity was further obscured, Vanderpant achieved an equal degree of abstraction purely through cropping. As obscure as the grain elevator may be in the reflection photo, it is the water and not the photographer that has distorted its form. The birds and silo image differs greatly, however, from his plant and vegetable series of images, or those of Weston, and the New York group, inasmuch as "the parts in the purpose of the whole" is not the objective. There is no reference or clue as to what the whole is, without

the straight documentary photo of Pool No. 1. Vanderpant, in this photo, has made "the part" the whole entity. Even Sheeler's *Pennsylvania Barn*, a flat, textured, abstract rendering of a side of a barn that fills the whole photograph, can be understood from a representational, realistic reading because a small quantity of straw and a chicken located at the bottom of the photo allows the viewer to get his bearings.

During a trip in 1935 to New York, Vanderpant shot many pictures. Yet these often lack the originality that had already been attained in the grain elevator series or was to come with the plant and vegetable series. Perhaps when visiting the skyscrapered metropolis where Ameri-

fig. 40
John Vanderpant
Pool No. 1 with Traintracks Foreground. c. 1934
silver bromide print
48.5 x 37 cm
Private Collection

can modern photography began, he wished to shoot it in the manner of the pioneers of straight photography.

Vanderpant's influence as a photographer did not extend beyond Vancouver and within the city it appears that it only went as far as a fellow photographer, John Helders. Helders, who also came from The Netherlands, lived briefly in Vancouver while working as catering manager at the Hotel Vancouver. An accomplished photographer in his own right, he often worked with Vanderpant and solicited his advice.

fig. 41
John Vanderpant
Untitled, c. 1934
silver bromide print
41 x 51 cm
Private Collection

fig. 42
John Vanderpant
Liquid Rhythm, c. 1934
silver bromide print
46 x 33 cm
Private Collection

CONCLUSION

It has been rare in the history of Canadian art that artists pulled together to produce an indigenous aesthetic. The Group of Seven did for a short while, as well as Borduas and his followers, and to an extent, the present abstract painters in Edmonton. Of course when there isn't a long tradition of strong artistic movements with prescribed philosophies, then it is difficult to react in order to promote a highly defined new direction. That is why it is absurd to think of Canadian art in terms of movements. Changing attitudes and allegiances, be they to a specific art association or to a dominant development in Western art in a very broad sense, is what should be documented.

The methods formulated by the present selection of Canadian artists to tackle the problem of creating abstract art, at times paralleled the artists to whom they were looking for guidance, and often each other in spite of the isolation in which they were working. It is not surprising, therefore, when one considers that Vanderpant was working through the aesthetics of straight photography that was, in part, influenced by cubist painting, and Marian Scott was working through modern painting aesthetics whose roots could be traced back to the same source, that their final images were often arrived at in the same way: cropping.

Regardless of the apparent affinities to American Cubo-Realism, it is now evident that the Canadian reaction to European modernism differed as much as Canadian and American culture. Even those Canadians who studied in the U.S. came back to Canada keeping what was relevant to them and adding their own personal interpretations. It would have made little sense for FitzGerald or Comfort to come back from New York and interpret Canadian society in terms of skyscrapers or staggering industrial wealth. Vanderpant was most original with his grain elevators, not his skyscrapers. And being less materialistic and pragmatic than Americans, the Canadians did not react as directly to the purely formalist aspect of Cubism but tempered it with a very strong element of sentiment, symbolism, and expressionism.

One of the pitfalls that artists exploring a foreign aesthetic can stumble into is grasping the design qualities of the style, while missing the substance. Lawren Harris teetered on the brink as his representational art became illustrative of, rather than embodying the practice of an early abstract expression. The modern image that has been discussed did become formulated into a very popular commercial design style and invaded architecture too. The Canadian government accidently designed a modern pavillion for the Paris World's Fair of 1937 (fig. 43) to prevent the view of the Eiffel Tower from being marred. Fortunately Harris, FitzGerald, Comfort, Scott, and Vanderpant did not have to make such compromises.

fig. 43
The Canadian Pavilion at the foot of the Eiffel Tower, Paris Exposition, 1937

NOTES

The Spread of Modern European Art to North America

1. catalogue in the archives of the Art Gallery of Ontario
2. catalogue in the archives of the Art Gallery of Ontario; information found in the unsigned introduction
3. ibid.
4. "American Artists Do Notable Work", *The Mail and Empire*, April (?) 8, 1921; "American Pictures Here Exemplify Mere Dexterity At Expense of Real Art", Allingham, *Sunday World*, January 16, 1921; "Exhibition of Antiques Proves To Be Real Test, American Pictures on Exhibit Show Powerful Treatment of Colors", *Weekly Star*, January 15, 1921, (signed M.L.F.); included in the archives of the Art Gallery of Ontario
5. archives of the Art Gallery of Ontario

Katherine Dreier, The Société Anonyme and The Canadian Connection

1. Letter of K.S. Dreier to Lawren Harris, August 26, 1926. Société Anonyme Papers, Yale Univesity. "Will you be so kind as to let me have two paintings in the same splendid modern spirit in which your *Ontario Hills* are painted."
2. Letter of K.S. Dreier to Lawren Harris, November 19, 1926. Société Anonyme File, Art Gallery of Ontario. In it she states that she will send *Mountain Forms* to the National Gallery of Canada after January 2, 1927.

 Letter of Dennis Reid, Art Gallery of Ontario, to Sandra Shaul, April 30, 1981. The painting was in storage at the Art Gallery of Toronto in 1934. After that, there is no record.
3. Letter of Lawren Harris to the exhibition committee of the Art Gallery of Toronto, (December 1926?). Société Anonyme File, Art Gallery of Ontario.
4. Bohan; abstract to thesis
5. ibid. thesis p. 24
6. ibid. p. 24
7. ibid. p. 252-255. As Ruth Bohan remarked in her thesis, the reviews from the *Toronto Globe* and the *Mail and Empire* were both glowing and comprehensive. The Globe critic, Lawrence Mason, had visited the Sturm Gallery in Berlin the previous summer and so was already familiar with the art in the exhibition.

Harris and the Dilemma of Nationalism vs Abstraction

1. Jeremy Adamson; *Urban Scenes and Wilderness Landscapes 1906-1930*, The Art Gallery of Ontario (Toronto) 1978
2. Harris first turned seriously to theosophy after his nervous breakdown in 1918. He was elected a member to the Toronto Theosophical Society in 1922 and wrote many articles and reviews with theosophical references.
3. Douglas Cooper; *The Cubist Epoch*, Phaidon in association with The Los Angeles County Museum of Art and The Metropolitan Museum of Art, 1971, p. 140
4. Jeremy Adamson; p. 138.
5. ibid.
6. ibid. p. 22. Adamson has presumed that Paul Thiem, an artist that Harris encountered in Berlin in 1907, was both a theosophist and a vital influence on the young Canadian.
7. ibid. p. 72
8. taped interview of Doris Heustis Mills by Charles Hill, October 15, 1973

9. Adamson; p. 126
10. ibid. p. 156
11. ibid. p. 203
12. ibid. p. 200. Adamson states that: "The Canadian landscape no longer held a magnetic attraction".
13. K.S. Dreier, *Modern Art*, Société Anonyme — Museum of Modern Art, (New York) 1926
14. Lawren Harris, "Creative Art and Canada", *Yearbook of the Arts in Canada*, 1928-1929. pp. 184-185
15. Harris and Dreier kept in touch with each other, at least by mail, until about 1931. In one letter, Harris asks her for advice about where his son should continue his art education.

 Letter of Lawren Harris to K.S. Dreier, April 19, 1931. Société Anonyme File, Art Gallery of Ontario

 They appear to lose contact until Dreier finds him again in Vancouver in 1949 to tell him that the Société Anonyme Collection, in which two small Harris sketches were included, was sold to Yale University in 1941 and that the cataloging of the Collection was almost finished for a 1950 publication date. Harris donated an abstract canvas to replace the two small sketches. Letters of K.S. Dreier to Lawren Harris, June 20, 1949, July 25, 1949, September 19, 1949, January 18, 1950. Letter of Lawren Harris to K.S. Dreier, December 9, 1949, Société Anonyme File, Art Gallery of Ontario

Lionel LeMoine FitzGerald: The Search for Structural Unity in Abstract Art

1. Although FitzGerald had exhibited for over ten years before his appointment, he indicated in his autobiographical notes (reprinted in Helen Coy; *FitzGerald as Printmaker*, The University of Manitoba Press Winnipeg, 1982) that he went to the Art Students League in 1921-22 because he felt "cer-

tain limitations hampering my work and the need of further study where school work could be combined with seeing outstanding works of art."

2. Letter of Lawren Harris to L.L. FitzGerald, 1928. FitzGerald Study Centre, School of Art, University of Manitoba

3. Brooker was far more astute a writer than a painter. If anything, his explorations of contemporary developments in modern art were often too literal. He appears to have realized this himself in a letter to FitzGerald: "While in New York a week or two ago, I saw a show of International art from twenty countries. The Canadian exhibit consisted of a Harris, Jackson, MacDonald, Lismer and a Casson, and when I came into the room where they were, I felt that all, with the exception of the Jackson, felt curiously out of place in the exhibition. They seemed to lack the quality which is difficult to explain, but which I can only call "painting". Alex *is* a painter. The others seem to go off either in a decorative, or romantic, or philosophical direction. You will perhaps be amused at hearing me talk in this kind of strain, in view of the kind of thing I do myself, but I don't pretend to be a "painter" in the strict sense in which I am using it here." Letter of Bertram Brooker to L.L. FitzGerald, March 20, 1933. FitzGerald Study Centre, School of Art, University of Manitoba

4. Charles Hill; *Canadian Painting in the Thirties*, The National Gallery of Canada (Ottawa) 1975, p. 21

5. FitzGerald Study Centre, School of Art, University of Manitoba

6. In 1930 FitzGerald travelled to Minneapolis, Chicago, Pittsburgh, Washington D.C., Philadelphia, New York, Montreal, Ottawa and Toronto to look at art education facilities.

7. Lionel LeMoine FitzGerald; *Unpublished Diary*, FitzGerald Study Centre, School of Art, University of Manitoba

8. FitzGerald; *Unpublished Diary*, June 7

9. ibid., June 20

10. FitzGerald's general remarks about the museum are amusing and telling: "I should imagine that the whole place is carried through the desire of the rich New Yorker for something different and the mystic feeling of it all I should think would appeal to a great many who are always looking for something new."

11. ibid., June 29

Charles Comfort: Expression, Design and Form
1. taped interview of Charles Comfort by Charles Hill, October 3, 1973

2. first prize, *Great Lakes Exhibition*, Buffalo, New York, 1938

3. Comfort received the following mural commissions:
 North American Life Assurance Company of Toronto, 1932,
 The Toronto Stock Exchange, 1936-37
 The Romance of Nickel, 1936-37 (This was commissioned by the International Nickel Company of Canada for the Paris Exposition and is currently installed in the Geocentre of the Mines and Resources Building, Ottawa.)
 Captain Vancouver, 1938-39 (Originally for the Hotel Vancouver, it is now installed in the Confederation Art Centre Library, Charlottetown, P.E.I.)

Marian Scott: The Balance of Structure and Expression in Abstract Art
1. correspondence between Marian Scott and Sandra Shaul initiated on April 15, 1981

2. ibid.

3. ibid.

4. ibid.

5. ibid.

6. ibid., In the catalogue, it is incorrectly titled *Way, Road, Street*!

John Vanderpant: A Pictorialist's Struggle with Modernism
1. Catherine B. Scallen; in chapter two of *Cubism and American Photography, 1910-1930*, Sterling and Francine Clark Art Institute (Williamston, Mass.) 1981, p. 24

2. Vanderpant opened the gallery in partnership with Harold Mortimer-Lamb but their partnership lasted for only one year. Charles Hill; *John Vanderpant Photographs*, The National Gallery of Canada (Ottawa), 1976, p. 17

3. Hill; *John Vanderpant Photographs*, p. 16

4. quoted in Hill; *John Vanderpant Photographs*, p. 17

5. Vanderpant quoted in Hill; *John Vanderpant Photographs*, p. 28

6. Hill; *John Vanderpant Photographs*, p. 28

7. quoted in Hill; *John Vanderpant Photographs*, p. 26

BIBLIOGRAPHY

Adamson, Jeremy; *Urban Scenes and Wilderness Landscapes 1906 - 1930*, The Art Gallery of Ontario (Toronto) 1978

Bohan, Ruth; *Société Anonyme's Brooklyn Exhibition*, UMI Research Press (Ann Arbor) 1982

Bovey, P., Davis, A.; *Lionel LeMoine FitzGerald 1890 - 1956: The Development of an Artist*, Winnipeg Art Gallery, 1978

Brooker Bertram, ed.; *Yearbook of the Arts in Canada*, 1928-29, and 1936, The MacMillan Company (Toronto)

Brown, Milton W.; *American Art From The Armory Show To The Depression*, Princeton University Press, 1955

Cooper, Douglas; *Cubist Epoch*, Phaidon in association with The Los Angeles County Museum of Art and The Metropolitan Museum of Art, 1971

Coy, Helen; *FitzGerald as Printmaker*, University of Manitoba Press (Winnipeg) 1982

Hayes B., Friedman, M., Millard, C.; *Charles Sheeler*, Smithsonian Institution Press (Washington) 1968

Hill, Charles; *Canadian Art in the Thirties*, National Gallery of Canada, 1975

Hill, Charles; *John Vanderpant Photographs*, National Gallery of Canada, 1976

Hoffman, Michael E., ed.; *Paul Strand, Sixty Years of Photographs*, Aperture, 1976

Homer, William Innes; *Alfred Stieglitz and the American Avant-Garde*, Secker and Warburg Ltd., (London) 1977

Pultz, John, and Scallen, Catherine B.; *Cubism and American Photography, 1910 - 1930*, Sterling and Francine Clark Art Institute, (Williamstown, Mass.) 1981

Rosenblum, Robert; *Cubism and Twentieth-Century Art*, Prentice-Hall Inc., and Harry N. Abrams (New York) 1976

Rourke, C.; *Charles Sheeler, Artist in the American Tradition*, Harcourt, Brace and Co. (New York) 1938

CATALOGUE OF EXHIBITION

1. Charles Comfort
 Tadoussac, 1935
 oil on board
 24.8 x 29.9 cm
 Collection of The National Gallery of Canada

2. Charles Comfort
 Tadoussac, 1935
 oil on canvas
 76.2 x 91.4 cm
 Collection of The National Gallery of Canada

3. Charles Comfort
 Smelter Stacks Copper Cliff, 1936
 oil on canvas
 101.6 x 127 cm
 Collection of The National Gallery of Canada

4. Charles Comfort
 The Silo, 1940
 oil on panel
 30.8 x 40.4 cm
 Collection of the Art Gallery of Ontario.
 Purchased in 1940

5. L.L. FitzGerald
 House and Trees in Winter, 1928
 red chalk on buff laid paper
 23.9 x 27.1 cm
 Collection of The National Gallery of Canada.
 Gift of the Douglas M. Duncan Collection,
 Toronto, 1970

6. L.L. FitzGerald
 Pritchard's Fence, c. 1928
 oil on canvas
 71.6 x 76.5 cm
 Collection of the Art Gallery of Ontario.
 Bequest of Isabel E.G. Lyle, 1951

7. L.L. FitzGerald
 Doc Snider's House, n.d.
 charcoal on paper
 24 x 28.3 cm
 Collection of The National Gallery of Canada

8. L.L. FitzGerald
 Trees No. 7, 1930
 graphite on wove paper
 34.8 x 27.8 cm
 Collection of The National Gallery of Canada.
 Gift of the Douglas M. Duncan Collection,
 1970

9. L.L. FitzGerald
 Untitled (Dead Trees), n.d.
 oil on canvas
 50.8 x 55.6 cm
 Collection of The National Gallery of Canada

10. L.L. FitzGerald
 Untitled, June 18, 1930
 pencil on paper
 20.2 x 20.5 cm
 FitzGerald Study Collection,
 University of Manitoba.
 Gift of Patricia L.F. Morrison and her heirs
 Earl and Patsy Green
 *Inscription: 102nd St. Roerich Museum
 June 18/30*

11. L.L. FitzGerald
 Untitled, (Tree and Building and Church),
 New York 1930
 pencil on paper
 23 x 18 cm (sight)
 FitzGerald Study Collection,
 University of Manitoba.
 Gift of Patricia L.F. Morrison Estate and her
 heirs Earl and Patsy Green

12. L.L. FitzGerald
 Farm Yard, 1931
 oil on canvas board
 34.9 x 42.5 cm
 Collection of The National Gallery of Canada

13. Lawren S. Harris
 North Shore, Lake Superior, c. 1926
 oil on canvas
 101.6 x 127 cm
 Collection of The National Gallery of Canada

14. Lawren S. Harris
 Lake Superior Sketch, c. 1927
 oil on pressed board
 30.2 x 38 cm
 Collection of The Edmonton Art Gallery.
 Gift of Mr. Robert Campbell, Edmonton

15. Lawren S. Harris
 Lake Superior III, c. 1928
 oil on canvas
 87.6 x 102.3 cm
 Collection of The National Gallery of Canada

16. Lawren S. Harris
 Father Point, c. 1929
 pencil on paper
 25.4 x 20.2 cm
 Collection of the Dalhousie Art Gallery.
 Purchased from Lawren P. Harris Jr. in 1976

17. Lawren S. Harris
 Lighthouse, Father Point, 1929
 oil on board
 30.5 x 38.1 cm
 Private Collection, Vancouver

18. Lawren S. Harris
 Lighthouse, Father Point, 1930
 oil on canvas
 106.7 x 127 cm
 Collection of The National Gallery of Canada

19. Lawren S. Harris
 North Shore, Baffin Island, 1930
 oil on board
 30.2 x 37.5 cm
 Collection of The National Gallery of Canada

20. Lawren S. Harris
 North Shore Baffin Island I, c. 1930
 oil on canvas
 81.3 x 106.7 cm
 Collection of The National Gallery of Canada

21. Lawren S. Harris
 Abstract Sketch, 1936
 oil on board
 37.8 x 30.2 cm
 Collection of The National Gallery of Canada

22. Lawren P. Harris Jr.
 House, Barn and Apple Tree, c. 1940
 oil on canvas
 40.6 x 50.8 cm
 Ontario Heritage Foundation Firestone Art
 Collection

23. Marian Scott
 Quebec Fields, 1931
 oil on canvas
 50.8 x 61 cm
 Ontario Heritage Foundation Firestone Art
 Collection

24. Marian Scott
 Escalator, 1936
 oil on panel
 60 x 44.9 cm
 Private Collection, Edmonton

25. Marian Scott
 Escalator, c. 1936
 oil on canvas
 57.2 x 76.2 cm
 Private Collection, Toronto

26. Marian Scott
 Fire Escape, 1938-39
 oil on canvas
 76.5 x 51.1 cm
 Collection of the Musée du Quebec

27. Marian Scott
 Cement, 1938-39
 oil on canvas
 58.4 x 67.3 cm
 Collection of the Faculty of Law,
 McGill University

28. Marian Scott
 Harbour, c. 1939
 oil on canvas
 74 x 51.2 cm
 Collection of The Edmonton Art Gallery.
 Purchased in 1980 with funds donated by
 Canada Permanent Trust

AMERICAN PAINTINGS

29. Stefan Hirsch
 Manhattan, 1921
 oil on canvas
 73.7 x 86.4 cm
 The Phillips Collection, Washington

30. Charles Sheeler
 Pertaining to Yachts and Yachting, 1922
 oil on canvas
 50.8 x 61 cm
 Collection of the
 Philadelphia Museum of Art
 Bequest of Margarett S. Hinchman

31. Niles Spencer
 City Walls, 1921
 oil on canvas
 100 x 73 cm
 Collection of the Museum of Modern Art,
 New York. Given Anonymously
 (by exchange) 1936

CANADIAN PHOTOGRAPHY

32. John Vanderpant
 The Work of Man, 1926
 silver bromide print
 49 x 37 cm
 Private Collection, Vancouver

33. John Vanderpant
Camp Town at Base of Rockies, c. 1929
(possibly C.N.R. series)
silver bromide print
28 x 35.5 cm
Private Collection, Vancouver

34. John Vanderpant
Call of the Ocean, 1929
silver bromide print
37.5 x 29 cm
Private Collection, Vancouver

35. John Vanderpant
Functional Beauty, 1929
silver bromide print
37.5 x 29 cm
Private Collection, Vancouver

36. John Vanderpant
Shadow From Bridge on Sidewalk, Feet Walking to Camera, 1929
silver bromide print
27.5 x 35 cm
Private Collection, Vancouver

37. John Vanderpant
Feet and Their Shadows 'Corpus Christie', n.d.
silver bromide print
35.5 x 28 cm
Private Collection, Vancouver

38. John Vanderpant
Picket Fence and Factory in Snow, n.d.
silver bromide print
35 x 27.5 cm
Private Collection, Vancouver

39. John Vanderpant
Untitled, c. 1929
silver bromide print
50.5 x 40.5 cm
Private Collection, Vancouver

40. John Vanderpant
Untitled, c. 1929
silver bromide print
50.5 x 40.5 cm
Private Collection, Vancouver

41. John Vanderpant
Untitled, September 1929
silver bromide print
41 x 51 cm
Private Collection, Vancouver

42. John Vanderpant
Three Pigeons, n.d.
silver bromide print
48 x 37 cm
Private Collection, Vancouver

43. John Vanderpant
Untitled, c. 1934
silver bromide print
41 x 51 cm
Private Collection, Vancouver

44. John Vanderpant
Liquid Rhythm, c. 1934
silver bromide print
42 x 33 cm
Private Collection, Vancouver

45. John Vanderpant
A Little Rhythm, n.d.
silver bromide print
46 x 33 cm
Private Collection, Vancouver

46. John Vanderpant
Broken Lines, c. 1934
silver bromide print
49 x 37 cm
Private Collection, Vancouver

47. John Vanderpant
Pool #1, With Traintracks Foreground, c. 1934
silver bromide print
48.5 x 37 cm
Private Collection, Vancouver

48. John Vanderpant
Cylinders & Cubes (Elevators and Buildings), 1934
silver bromide print
51 x 41 cm
Private Collection, Vancouver

49. John Vanderpant
Joy of Winter, n.d.
silver bromide print
27 x 35 cm
Private Collection, Vancouver

50. John Vanderpant
The Fence Casts a Shadow, n.d.
silver bromide print
41 x 51 cm
Private Collection, Vancouver

51. John Vanderpant
Shadow From Fence on Sidewalk, Feet Walking Away, c. 1934
silver bromide print
27.5 x 35.5 cm
Private Collection, Vancouver

52. John Vanderpant
Jars and Cup and Saucer, n.d.
silver bromide print
50.5 x 40.5 cm
Private Collection, Vancouver

53. John Vanderpant
Stems of Daffodils in Clear Bowl, 1935
silver bromide print
35 x 27.5 cm
Private Collection, Vancouver

54. John Vanderpant
Three Million Windowed Building From Another Angle, c. 1935
silver bromide print
51 x 41 cm
Private Collection, Vancouver

55. John Vanderpant
Spirit and Matter #2, c. 1935
silver bromide print
51 x 41 cm
Private Collection, Vancouver

56. John Vanderpant
Idealism, c. 1935
silver bromide print
41 x 32.5 cm
Private Collection, Vancouver

57. John Vanderpant
Brooklyn Bridge, c. 1935
silver bromide print
50.5 x 40.5 cm
Private Collection, Vancouver

58. John Vanderpant
Steel Spider's Web, c. 1935
silver bromide print
35.5 x 27.5 cm
Private Collection

59. John Helders
The Chateau Roofs (Into the Dark), 1926
silver bromide print
34.3 x 27.5 cm
Collection of the Vancouver Public Library

60. John Helders
Brooklyn Bridge, 1927
silver bromide print
41.8 x 24.1 cm
Collection of the Vancouver Public Library

61. John Helders
The House of Mammon, 1932
silver bromide print
43 x 34.6 cm
Collection of the Vancouver Public Library

62. John Helders
Light and Shade, c. 1937
silver bromide print
41.9 x 32.7 cm
Collection of the Vancouver Public Library

63. John Helders
Pool No. 1, 1937
silver bromide print
42.9 x 33.7 cm
Collection of the Vancouver Public Library

AMERICAN PHOTOGRAPHY

64. Aaron Siskind
Bucks County Barn 29, 1936-37
gelatin silver print
18.9 x 23.9 cm
Collection of The National Gallery of Canada

65. Ralph Steiner
New York City, c. 1930
silver gelatin print
24.1 x 19.1 cm
Collection of The National Gallery of Canada

66. Paul Strand
Photograph — New York, 1916
photogravure, published in *Camera Work*
June 1917
21.7 x 16.7 cm
Collection of The National Gallery of Canada

67. Paul Strand
White Fence, Port Kent, New York, 1916
photogravure, published in *Camera Work*,
June 1917
17 x 22 cm
Collection of The National Gallery of Canada

68. Paul Strand
Abstraction, Porch Shadows, Twin Lake,
Conneticut, 1916
photogravure, published in *Camera Work*,
June 1917
24.2 x 16.2 cm
Collection of The National Gallery of Canada

69. Paul Strand
Double Akeley, c. 1922
gelatin silver print
24.5 x 19.4 cm
Collection of The Museum of Modern Art,
New York. Purchased as the gift of Mrs.
Armand P. Bartos

70. Paul Strand
Fox River, Gaspé, 1936
gelatin silver print
12.2 x 15.4 cm
Collection of The National Gallery of Canada

71. Edward Weston
Steel, c. 1922
gelatin silver print
23.4 x 17 cm
Collection of The National Gallery of Canada

72. Edward Weston
Pennsylvania Dutch Barn, 1941
gelatin silver print
18.7 x 23.9 cm
Collection of The National Gallery of Canada